CLEVELAND IN THE GILDED AGE

A STROLL DOWN MILLIONAIRES' ROW

DAN RUMINSKI & ALAN DUTKA

WITH CONTRIBUTIONS BY
STEVE ERLICH, WESTERN RESERVE HISTORICAL SOCIETY
THE RUMINSKIS (SUSAN, ADELE AND WALTER)
SARA'S GROUP, CLEVELAND CLINIC ARCHIVES DEPARTMENT

THE
History
PRESS

We dedicate this book to children throughout the world and to the unsung heroes who care for and nurture these special beings: their parents.

Your work in so many cases is seen as an inspiration to all who have the privilege to observe.

Published by The History Press
Charleston, SC 29403
www.historypress.net

Copyright © 2012 by Dan Ruminski and Alan Dutka
All rights reserved

First published 2012
Second printing 2013
Third printing 2013

Manufactured in the United States

ISBN 978.1.60949.878.8

Library of Congress Cataloging-in-Publication Data

Ruminski, Dan.
Cleveland in the Gilded Age : a stroll down Millionaires' Row / Dan Ruminski and Alan
Dutka.
pages cm
ISBN 978-1-60949-878-8
1. Cleveland (Ohio)--History--19th century. 2. Cleveland (Ohio)--History--20th century.
3. Millionaires--Ohio--Cleveland--Biography. 4. Cleveland (Ohio)--Biography. 5.
Millionaires--Homes and haunts--Ohio--Cleveland. 6. Historic buildings--Ohio--Cleveland.
7. Mansions--Ohio--Cleveland--History. 8. Cleveland (Ohio)--Buildings, structures, etc. I.
Dutka, Alan, 1942- II. Title.
F499.C657R86 2012
977.1'32--dc23
2012045951

CONTENTS

ACKNOWLEDGEMENTS

The following individuals provided significant contributions to this book:

CLEVELAND PUBLIC LIBRARY
Beverly Austin (history)
Margaret Baughman (photographs)
Ronald Berdick (history)
Stacie Brisker (Special Collections)
Nicholas Durda (photographs)
Thomas Edwards (map collection)
Patrice Hamiter (photographs)
Michael Jacobs (Special Collections)
Chris Wood (history)

CLEVELAND STATE UNIVERSITY
William C. Barrow (Special Collections)
Lynn M. Duchez Bycko (Special Collections)

INDIVIDUALS
Priscilla Dutka
Diane Dutka
Craig de Fasselle
Sara de Fasselle

INTRODUCTION

How does one become Cleveland's storyteller? My journey actually started four years ago at a wonderful little library in Gates Mills, Ohio. It was one of those rainy, winter Saturday mornings in February, and I had nothing planned for the day. Upon awakening, I turned to my dear wife, Sue, to suggest that I might go to the library to do some reading. Dear Sue gave me that famous look of hers, as if to say, "No way are you going to the library. You just want to go to breakfast with your buddies." Well, normally, dear Sue would have been correct, but in this case, I was going to make an extremely rare visit to the library.

My vision for the day was actually to do some research, for you see, I live on a very historical piece of property formerly owned by Walter White, founding brother of the White Motor Company. I own six acres of the once famous Circle W Farm, Walter's grand estate. For whatever reason, I wanted to learn what my property was used for in 1920—was it a cornfield, hay field or just a tree farm, as Walter planted thousands of trees so future generations could enjoy them. Walter and his family spent much time in Gates Mills, Ohio, once upon a time; he was a founding member of the Gates Mills Hunt Club, a well-known club throughout the country known for its polo team and other activities. Thus, just maybe the Gates Mills Library had what I was looking for.

A visit to the Gates Mills Library, I found, became very special. As I walked in with coffee in hand, I approached a young lady who obviously worked for the library, requesting information on the Walter White estate. The young

lady turned out to be Katherine, head librarian. Katherine suggested a couple of books that I promptly found. I settled in a nice armchair in front of the fireplace and began to read a most fascinating story about Walter and his brother, Windsor, and their great estates.

My recollection of that morning is that about an hour into my research I received a tap on the shoulder from my new friend Katherine. She wanted me to meet her friend Sally Burke, president of Gates Mills Historical Society. After exchanging introductions, Sally, being in the history business, so to speak, asked if I would be willing to put together a presentation on these two great estates. She explained that most libraries have a group known as Friends of the Library, and they sponsor various speakers on a monthly basis. My Saturday now became most interesting in that I was faced with a decision that was about to change my life in a very significant fashion. I answered Sally almost instantly by saying, "Yes." Never one to back down from an opportunity, I asked Sally how many people normally attended such an event. She told me a group of forty would represent a very successful event. We agreed to a date, and instantly I was put into the history business.

Once I returned home that afternoon, it finally hit me in terms of what I had just committed to. I now had to prepare a one-hour presentation on a subject I knew next to nothing about. Being a former schoolteacher, I believed I could do this, but now reality took the fun out of my wonderful Saturday morning. As is my habit, I procrastinated until the last two weeks before D-day, doing my homework and rehearsal at the last minute. Two days before that April Sunday, I completed the task at hand and was ready to make history, so to speak.

The day of my presentation, I arrived early, as is my habit, to get a feel for the room and also to make sure I knew my subject. I do not remember why, but I decided I would put this information into a story; thus, I would use no notes or anything else that would help me stay on track. The library and my friend Katherine had set up forty chairs, as is customary for such events. Finally, the hour of 2:00 p.m. approached, and to my complete surprise, people actually began to arrive to hear a fellow give a history talk. Amazingly, though, people kept coming and coming. When all was said and done, over 150 folks turned out to hear a very nervous storyteller give his first presentation.

Katherine decided she would introduce me, and she was extremely pleased with the audience. Unknown to me at the time, in the audience there were seven White family members. Katherine, who does have a sense of humor, made sure to recognize all seven during her introduction, knowing that I was

now the next step beyond nervous. The time had arrived, and as I eased into my story, I actually became very comfortable as the audience reacted to what I had to say. I also felt a great sense of enjoyment as my forty-five minutes of presentation passed very quickly.

All finished well, and my audience had many questions upon my completion. I seem to remember that questions took an additional forty-five minutes, which I believe pleased Katherine—this was a sign of a good presentation. As a side note, the White family suggested to me that they learned many things they did not know about their most successful past relatives. I see this time and time again today as family information seems to get drastically defused with third and fourth generations. Today, I am a friend of the Whites, and they have come to many of my talks. Thus, my magical Saturday afternoon came to an end with me being on cloud nine, having accomplished something that I had no idea I could do. I guess there is a lesson here for you, reader. At any rate, I was content, for now I could return to making a living and playing golf, as spring was upon us.

Life sometimes has plans for us that we ourselves could never imagine. In my case, four years ago, life was about to change in a remarkable way. Since my first talk at the Gates Mills Library was so unexpectedly successful, head librarian Katherine suggested, in no uncertain terms, that I must return and do it again. Since I enjoyed my first talk so much when all was said and done, I agreed. A date was scheduled, and again, remarkably, over one hundred people showed up to hear Dan Ruminski, storyteller. Needless to say, libraries do communicate with one another, and soon enough I was getting calls from all over the Greater Cleveland area wanting me to share my story with their patrons. As this continued, my presentations grew to over seventy per year. Time, in passing, allowed me to create several stories about Cleveland history. This book is the written version of my stories. I developed a format of bringing in fifty to sixty pictures that related to each story and displayed them before and after my talk. The presentation itself has remained unchanged over the years, as I sit in my chair and tell stories of this rich Cleveland history.

I cannot remember quite when, but I discovered that a mission statement relating to my presentations might be in order. Using Cleveland's fabulous history to promote greater pride in the city seemed appropriate and meaningful. The folks of Cleveland would now have positive responses to those nasty, negative stereotypes with which most of us are all too familiar. I found time and time again that my audiences longed to be proud of their city. For most big cities, it is their sports teams that help facilitate this pride.

INTRODUCTION

In this department, Cleveland has not done well in recent history. I, as a storyteller, telling stories of Cleveland's early history, can bring pride to Cleveland audiences—what a novel approach!

I also believe that audiences beyond the Greater Cleveland area may find this history interesting and entertaining. Great accomplishments remain great no matter where they take place. I believe that upon reading the following, folks may come away with a very positive view of our Cleveland, Ohio.

The following chapters are somewhat novel in that portions of each chapter, written by my friend and coauthor Alan Dutka, give you, our reader, the rather textbook history of each of our stories. Interspersed are sections I wrote that go into a more personal side of each story. Through my years of research, I have come across gems of information that I was most anxious to share with our readers. In most cases, information was attained from family members of my cast of characters. Such information is not found in traditional sources. My audiences, over the years, have reacted in a very positive way to this personal information. Thus, Alan and I hope you will truly enjoy the following and hope you may find food for thought in what you are about to read.

1

Millionaires' Row

The Avenue of Wealth and Power

Millionaires' Row, Euclid Avenue, Cleveland, Ohio—what was it, and what made it so very special? I believe to truly understand the greatness of "The Row," one must first examine Cleveland, Ohio, from about 1850 to 1929.

"Cleveland, Ohio—the greatest and wealthiest city in the entire world" is quite a statement, and surely any reader would have the right to question what authority this is based on. Well, one fact has appeared over and over again in my research: half of all the world's millionaires lived in Cleveland, Ohio, in about 1885. We were the city known throughout the world. We were Silicon Valley times ten. Folks as far away as Russia knew of Cleveland and its world-famous Millionaires' Row. The world was also well aware of the wealthy cast of characters who resided in Cleveland: Rockefeller, Mather, Hanna, Stone and Wade. These folks were as well known as any movie star today.

Mark Twain referred to Euclid Avenue as "one of the finest streets in America." He praised the street's stunning mansions and called its equally beautiful yards "something marvelous." Sophisticated world travelers spoke of Euclid Avenue in the same breath as Avenue des Champs-Élysées in Paris and Unter den Linden in Berlin. Bayaard Taylor, an author, world traveler and "poet of the Gilded Age," speaking in Great Britain in the 1860s, called Euclid Avenue the "most beautiful street in the world," conceding Nevsky Prospect in St. Petersburg as the only serious rival. At the turn of the twentieth century, the influential *Baedeker's Travel Guide* called Euclid Avenue

the "Showplace of America," recommending the elm-lined street as an essential tourist destination for travelers from Europe.

How did Mark Twain know about Euclid Avenue? As it so happens, Twain, through a series of events, became friends with the Severance family—yes, the Severance Hall folks, home to our Cleveland Orchestra. Mark Twain traveled extensively with the Severances, oftentimes going to Europe with them. Twain was so impressed with the avenue that in a letter to his fiancée he suggested they might want to live on Euclid Avenue.

U.S. presidents visited at least three of the avenue's mansions; one of the homes hosted six presidents. As the nineteenth century drew near its close, Euclid Avenue's concentration of wealth and influence remained unchallenged. On February 11, 1892, the *New York Tribune* published its assessment of America's wealthiest individuals; fifty-three of the top sixty-eight resided on Euclid Avenue. The tax valuation of the street's mansions dwarfed those of New York's Fifth Avenue.

Initially, "Millionaires' Row" encompassed mansions located between East 20th and 40th Streets, but the wealth and extravagant living soon expanded eastward toward University Circle, while numerous stately homes also existed to the west, between Public Square and East 20th Street. In total, more than 300 grand residences once lined the four-mile expanse between Public Square and East 105th Street, although not all of the homes existed at the same time. Millionaires demolished some of the original structures to build even grander homes. In the 1890s, Cleveland's procession of prosperity incorporated about 260 houses. Industrial tycoons, railroad barons, influential bankers and lawyers, wealthy politicians, prosperous scientists and even a notorious swindler resided in mansions that defined Cleveland's prosperity in the late nineteenth century.

Euclid Avenue was so much more than just a beautiful street; it was also a legitimate neighborhood with marvelous mansions mixed in with grand churches, all architecturally blended to create a fantastic vision.

I believe Cleveland's greatness can be explained. I believe it can be demonstrated through a series of stories that exemplify the fact that Cleveland, Ohio, was involved in every aspect of society worldwide. Sometimes, good stories serve to bring a point like this home better than any other vehicles. Stories that reflect the divergence of what Cleveland accomplished to foster world growth might do more to make this point than anything else I could do. Let us see if you agree.

Cleveland, Ohio, at the turn of the century (1900) had a fellow in business by the name of Clarence Crane. Clarence was a candy maker

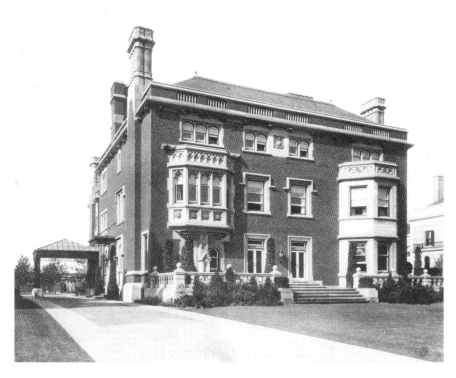

Mather's forty-three-room mansion still exists, a memorial to Euclid Avenue's former wealth and power. *Courtesy of Cleveland Public Library, Photographic Collection.*

and invented a hard candy that we still enjoy today. This hard candy has a hole in the middle of it. You may have already guessed that the candy in question is none other than the Lifesaver. Well, Clarence achieved good success with his candy, and this attracted the attention of a fellow in New York by the name of Ed Noble. Ed was in the advertising business, selling space on postcards that contained pictures of famous people and places most people wanted to see. One of the most famous postcards was a picture of the gatehouse leading into John D. Rockefeller's estate, known as Forest Hills. Well, Ed came to Cleveland to see Clarence, and upon tasting the candy he thought a better idea was to buy the company. Ed paid Clarence all of $3,900, a good amount for the times. Ed then took Lifesavers to a whole new dimension and, over the next years, saved his money—about $9 million. Now, Ed wanted to buy another little company, so he did. For $9 million, Ed bought an upstart company. You would know it today as ABC, the American Broadcasting Company.

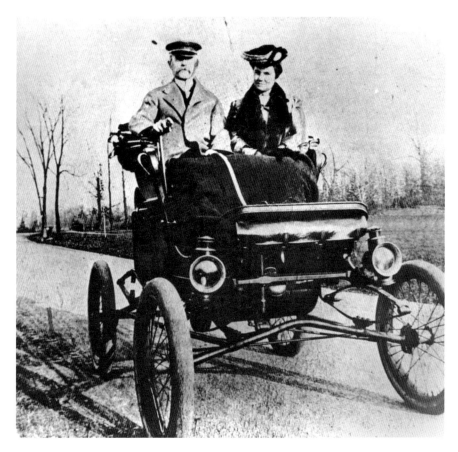

In 1900, this White Steamer is shown driving on Cleveland's Edgewater Drive. *Courtesy of Cleveland State University, Cleveland Press Collection.*

There was another world-famous event that Cleveland made possible, changing the world forever. Charles Lindbergh had a dream to fly across the Atlantic. A very special aircraft was needed to accomplish this task, and it took special companies to do this. Paint by Sherwin Williams, gauges by Parker Appliance, motor mounts by Park Drop Forge and special valves for the engine by Thompson Products—all Cleveland companies. Without Cleveland, maybe there never would have been a Charles Lindbergh as we know him today. I am just suggesting that Cleveland's role in the aircraft industry was huge.

Automobiles and their beginnings are associated with Detroit as the founder of this industry. Not so. Cleveland contained over three hundred

manufacturers of the finest autos in the entire world. My three favorites are Baker Electric 1898, the Winton 1898 and the White Steam touring car 1900. It struck me that the technology here in Cleveland in 1900 was better or at least equal to what we get today, let's say, from General Motors.

Upon reading about these three autos, I was motivated to write a letter to the president of General Motors to see if he had studied them. After all, GM had just introduced its revolutionary Chevy Volt, an electric car, which got all of 40 miles per charge. My, oh my, Baker's electric car, in 1898, got 40 miles per charge. GM also, in recent history, introduced its revolutionary 100,000-mile warranty. In my letter, I could not resist including a quote I had read from Walter White, president of the White Motor Company, in 1921. Walter put it wonderfully, and I quote, "The Honor of the White Family name is part of each automobile we build and all must last at least 100,000 miles." I believe this statement from White somewhat defines this wonderful period in Cleveland's history and gives us a clue as to how to return to greatness. (By the way, the president of General Motors did answer my letter, thanking me for writing. He did not comment on just how little progress GM seems to have made over the last one hundred years or that it bothered to look at this history and at least set goals to exceed what was accomplished in 1900.)

Candy, aircraft, cars, Cleveland millionaires...Ohio had it all.

When Downtown Flaunted Mansions: Handy, Stone and Hay

Prior to the millionaires' penchant for excessive extravagance, banker Truman P. Handy's elegant Greek revival residence ranked among Euclid Avenue's finest homes. Constructed in 1837 and remaining in existence for sixty-six years, the structure satisfied Handy's self-image for a paltry four years. During his brief stay at this home, Handy increased his wealth by financing railroads and businesses. Reflecting his enhanced prominence within the community, he moved eleven blocks eastward, erecting an even greater home. Wealthy dry goods merchant Elisha Taylor purchased Handy's first home, later the residence of Cleveland mayor George Senter, an enterprising politician who also owned a wine and liquor business. After Senter died, the fashionable Union Club used the mansion as its

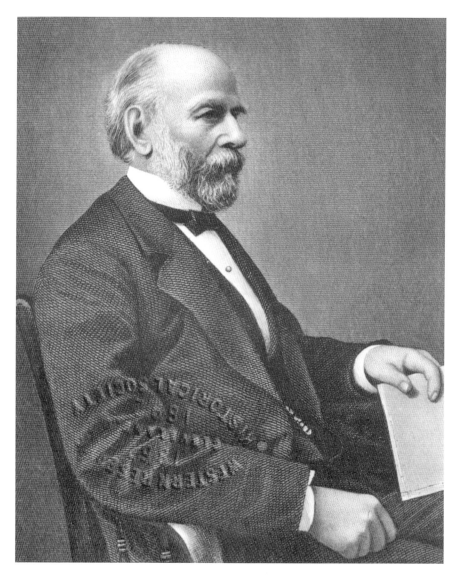

Amasa Stone constructed one of Euclid Avenue's earliest mansions but died in his beautiful home of a self-inflicted gunshot wound. *Courtesy of Cleveland Public Library, Photographic Collection.*

headquarters from 1872 to 1902. Both of Handy's residences have been demolished; the first made way for the Hippodrome Theatre (now the site of a parking garage), while Cleveland State University's John Marshall College of Law resides on the latter site.

A Stroll Down Millionaires' Row

In 1858, Amasa Stone, a successful railroad entrepreneur and bridge designer, erected a 6,500-square-foot Italianate villa mansion. Eighteen years later, Stone planned and constructed a bridge spanning the Ashtabula Gorge, ignoring advice from his own engineers, who considered the design unsafe. The bridge ultimately collapsed in a windstorm, killing 151 train passengers unfortunate enough to be crossing at the time of its collapse.

The despondent Stone, attempting to cope with the bridge disaster, failing health, the accidental drowning of his only son and a financial panic that ruined three companies he controlled, fired a bullet through his heart while sitting in a bathtub in his Euclid Avenue mansion. Samuel Mather and his wife, Flora Stone Mather (one of Amasa's daughters), lived in the home until Flora died in 1909. At the time of her death, Flora had nearly completed her participation in the design of what would have been her next residence, the plush Mather mansion still standing on the Cleveland State University campus. After the Stone residence's demolition in 1910, two major Cleveland department stores (the Higbee Company followed by Sterling Linder Davis) used a newly constructed building for their retail locations. The building is still standing on the northwest corner of Euclid Avenue and East Thirteenth Street.

I thought it might be interesting to the reader to talk about some of the families who actually lived on The Row. Over the years, this group was made up of over three hundred families, all wealthy and successful, and most the best in their fields of endeavor. To talk about three hundred families would make for a longer book than I have the energy to write, so I have decided on three families whose names you may recognize: Mather, Rockefeller and Drury. I selected these three because they have name recognition, for the most part. Also, their stories are interesting and educational and may even provide a little lesson. I find these families all had something in common: a hobby that I share and enjoy doing very much.

Our first family, the Samuel Mather family, is an old-line Cleveland family of great importance and wealth. Samuel Mather was raised in Cleveland by a wealthy father, who—if one can believe it—owned a farm of some 150 acres along Euclid Avenue. The Mather fortune was made on many fronts, including mining and shipping iron ore, shipbuilding, steel making and banking. Mather could be considered typical of many families who lived on The Row in that many were extremely diversified in wealth accumulation. The Mather family was hardworking, religious and charitable.

Samuel Mather was a member of Trinity Cathedral Church, now in the area of East Twenty-second and Euclid Avenue. Mather was a board member of the church and was also entitled to his own pew for all services.

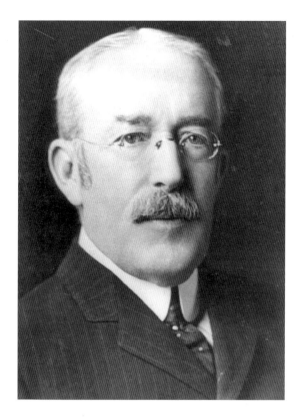

Samuel Mather turned his father's successful iron ore and coal mining business into an even more profitable company. *Courtesy of Cleveland State University, Cleveland Press Collection.*

Anybody attempting to sit in the Mather pew was always asked nicely to move, for Mather expected his pew to be available to him and his family at all times. Samuel earned this little benefit as a board member. If the church was in the red at year's end, Mather and fellow board members would divide the debt themselves and each write a personal check to return the church to debt-free status for the upcoming year.

Sometime after the turn of the century, it was time to build a new, bigger church that resulted in the one we enjoy driving by today. Mather took charge of this project and began working with well-known Millionaires' Row architect Charles Schweinfurth. Schweinfurth's work is evident today not only in the church but also in the Mather mansion, conveniently owned by Cleveland State University. Other works that you might enjoy today are the three wonderful bridges that cross over Martin Luther King Boulevard. Well, monies used to build this church turned out to be short by $1 million. Schweinfurth approached Mather to explain that he could work around this shortfall, and when monies were raised, they could finish the church.

Sam Mather, in his later years, became somewhat impatient, and he very well could afford to be impatient because he had enough money to fix most situations (his net worth was about $100 million). Mather told Schweinfurth that he would come up with a solution so that the entire church could be built at one time.

Sam Mather quickly came up with the answer. He called his personal secretary and told her to write a check from his personal account for $1 million. The personal secretary seemed to be confused, and in his impatience, Mather asked her what the problem was. Her answer was: "Mr. Mather, you have several personal accounts with $1 million. Which one shall I draw the check from?" Needless to say, a completed beautiful church was built with Mather as a key building block.

Once the church was completed, Sam Mather had another building project in mind. This was his own $3 million mansion, which Schweinfurth was to design. Mather was married to Flora Stone, a well-known Clevelander in her own right (her father, Amasa Stone, was a well-known resident of The Row who had made his fortune building railroad lines). As was customary with many families on Euclid Avenue at the time, daughters and husbands would move in with parents until such a time when a proper home could be built for the newlyweds. Samuel and Flora began design of their home around 1908; Mather built close to downtown Cleveland, for he feared the families of The Row were already making for points farther east and west. In other words, he already recognized the decline of our wonderful Euclid Avenue as a neighborhood and hoped that by building a new grand mansion, he could help preserve the residential character of Euclid Avenue. Sadly, Flora Stone Mather died of breast cancer about one year before the Mather home was completed. She actually never saw the finished product. Mather's daughter Constance became the mistress of the house, taking over the many duties of her departed mother.

Flora Stone Mather was very active within Western Reserve University in Cleveland, founding the women's college as part of this institution. Upon her death, Sam Mather did much to move the university forward in his wife's honor; thus, many a building today has the name of Flora Stone Mather. Mather and his son-in-law, Dr. Bishop, championed another project: the promotion and building of University Hospital, today a world-renowned medical center located in Cleveland.

John Milton Hay, employed as a *New York Tribune* journalist, met Clara Louise Stone (another daughter of Amasa Stone) while visiting the New York residence of Clara's uncle. After a long-distance courtship, John

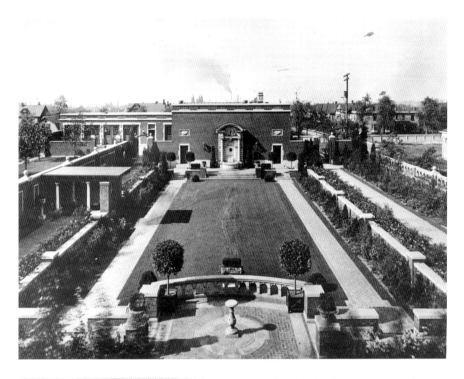

Above: The Mather home once contained this extravagant backyard. *Courtesy of Cleveland Public Library, Photographic Collection.*

Left: Flora Stone Mather died as she finished preparations for her move to the Mather mansion, still located on Euclid Avenue. *Courtesy of Cleveland State University, Cleveland Press Collection.*

Future secretary of state John Hay lived on Millionaires' Row for about twelve years. *Courtesy of Cleveland Public Library, Photographic Collection.*

and Clara married, residing in Cleveland from 1875 to 1886 while John worked in his father-in-law's business. Besides offering Hay a new career, Clara also brought significant wealth to the marriage. Previously, Hay had studied law with his uncle in an Illinois office adjoining the workplace of aspiring political leader Abraham Lincoln. When elected president, Lincoln chose Hay as his private secretary. Hay even resided in the White House. Following Lincoln's assassination, Hay obtained political appointments to Paris, Vienna and Madrid.

While in Cleveland, Hay lived in a Euclid Avenue mansion next to his father-in-law. The Higbee and Sterling Linder Davis department store building also replaced the Hay mansion, in existence for only thirty-four years. In 1886, Hay moved his family from Cleveland to Washington. Campaigning for William McKinley in 1896, the victor rewarded Hay with an appointment as ambassador to Great Britain. As secretary of state in both the McKinley and Theodore Roosevelt administrations, Hay remained the only person to have resided in the White House prior to becoming secretary of state until the appointment of Hillary Clinton.

JOHN D. ROCKEFELLER: A MODEST HOME CONCEALS A PERVASIVE INFLUENCE

John D. Rockefeller, a Euclid Avenue resident from 1868 to 1884, is certainly the most recognizable luminary among the street's rich populace. Not adhering to the norms of Cleveland society, Rockefeller not only purchased a pre-owned home but also chose to live on what the upper crust deemed the less desirable side of the street. The most affluent millionaires generally preferred the north side, with its views of Lake Erie; the less wealthy resided to the south, where Rockefeller selected his more modest home (3920 Euclid Avenue). Ironically, a gas station eventually replaced Rockefeller's residence.

Some of Rockefeller's business associates, acquiring their wealth largely through John D.'s success, chose to flaunt expensive residences on the socially proper north side of the street, while a few followed Rockefeller's example by residing on Euclid Avenue's south side. Six Rockefeller partners (Samuel Andrews, Steven Harkness, Harry Flagler, Herman Frasch, Earl W. Oglebay and David Z. Norton) offer surprising contrasts in career and lifestyle preferences.

Samuel Andrews opposed Rockefeller's policy of continually reinvesting most of the company's profits back into the business instead of rewarding investors with hefty dividends. In 1874, weary of Andrews's relentless bickering, Rockefeller asked him to name his price to withdraw from the company. Andrews requested $1 million; Rockefeller produced the check the following morning. A million dollars constituted a tidy sum in the nineteenth century, but Andrews's financial reward paled in comparison to the wealth accumulated by Steven Harkness, another early investor in Standard Oil. Harkness's initial investment of about $75,000 escalated to more than $300 million under John D. Rockefeller's astute guidance.

Andrews's bitterness toward Rockefeller intensified as Standard Oil's shareholders prospered almost beyond belief. He flaunted his much lesser wealth by building Euclid Avenue's most extravagant mansion. Under construction for three years beginning in 1882, this excessive, if not bizarre, English manor house combined Victorian and Gothic styles. Building and furnishing the home consumed approximately $1 million. Located on the northwest corner of Euclid Avenue and East Thirtieth Street, the house contained thirty-three major rooms and nearly one hundred rooms in total. The vast mansion required employment of about one hundred servants, including chefs, cooks, maids, housekeepers, maintenance workers, carriage

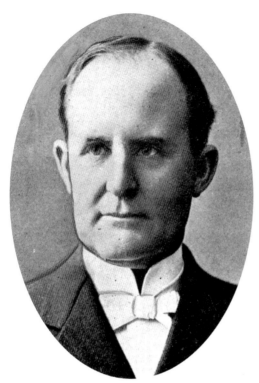

Earl W. Oglebay lived in two Millionaires' Row mansions while earning a fortune mining iron ore in Michigan and Wisconsin. *Courtesy of Cleveland State University, Cleveland Press Collection.*

men and hostlers. Later known as "Andrews's Folly," its impractical floor plan resulted in operational inefficiencies and huge maintenance expenses.

While United States presidents and titans of industry visited Millionaires' Row homes, Andrews set his sights on entertaining Queen Victoria, an event that never transpired. In fact, Andrews and his family relocated to New York after living in the home for only three years. Following Andrews's death in 1904, his son Horace occasionally visited the mansion, even living in it for brief periods. In the early 1920s, a Cleveland-based movie company used the home as a set for three silent films. But for the most part, the mansion remained both completely furnished and totally vacant for more than three decades, until succumbing to demolition in 1923.

Following the demise of Andrews's Folly, the land remained unused for more than thirty years, except for a short-lived gas station and the Hole in One, a driving range for golf enthusiasts. In 1957, television station WEWS constructed a still-existing studio and offices on part of the property. Several buildings north and east of the television complex also reside on the old mansion's former site.

Samuel Andrews, Stephen Vanderburgh Harkness and Henry Morrison Flagler composed Rockefeller's three major Standard Oil partners. Harkness and Flagler, not sharing a common parent, grew up together as stepbrothers. After two-year-old Harkness suffered the loss of his mother, his remarried father died before Stephen reached the age of eight. Stephen's stepmother subsequently married a Presbyterian minister, and their union produced Henry Flagler.

Harkness apprenticed as a harness maker but achieved early success by owning a distillery. He entered the fledging oil refining industry, eventually partnering with John D. Rockefeller. The exceedingly prosperous Harkness constructed a stately Italianate villa on the less expensive south side of the street (6508 Euclid Avenue). A dentist later used the mansion as an office; today, the site contains a boarded-up and decaying building.

Henry Flagler began his career working in his uncle's store in Bellevue, Ohio. After failing as the owner of a salt mining business, he attained success as a grain commission merchant, in the process meeting John D. Rockefeller, who worked in a similar capacity. This business relationship eventually led to their partnership in Standard Oil. Achieving millionaire status as a Standard Oil stockholder, Flagler constructed an admirable home (3725 Euclid Avenue).

Flagler and his wife traveled to Jacksonville, unsuccessfully attempting to cure her illness. After his wife's death, Flagler married her caregiver, and the two spent their honeymoon in Saint Augustine. Flagler's fascination with Florida muted his interest in Standard Oil. He built railroads, homes, hotels, streets, bridges and water and power systems to develop and connect Miami, Saint Augustine, Palm Beach and other nearby cities. Flagler contributed to the construction of hospitals, churches and schools. Today, a statue of Henry Flagler rests on the steps of Dade County's courthouse, located on Flagler Street, Miami's major east–west artery. In Cleveland, Flagler's Euclid Avenue residence existed for only fifteen years. Charles Brush purchased and demolished the home to construct one of Euclid Avenue's most prominent mansions.

German-born chemist Herman Frasch invented processes to cost effectively extract sulfur deposits, remove sulfur from crude oil and refine paraffin wax from petroleum. Aware of these applications, Standard Oil hired Frasch as a researcher who worked in Cleveland from 1877 to 1885. Frasch purchased an eighteen-room sandstone Victorian villa originally constructed in 1878 by shipbuilder Rufus K. Winslow. Leaving Standard Oil to establish his own oil business, Frasch continued to develop innovations.

He subsequently sold his company and its patents to Standard Oil, enabling Rockefeller to use mediocre crude supplies in his production of first-rate refined oil. After founding the Union Sulfur Company, another successful business, Frasch retired, relocating to Paris.

In 1930, the National Town and Country Club constructed a twenty-two-floor Art Deco building, designed by New York's George Post & Sons, on the site of the earlier Winslow/Frasch residence. Inaugurated at the onset of the Great Depression, the ill-fated social establishment, geared to attract Cleveland's "new" early twentieth-century money, failed after staging its initial event, a Christmas lunch. Seven years later, Fenn College purchased the abandoned building, renaming it Fenn Tower. Now a dormitory, the tower is part of the Cleveland State University campus.

Although the Standard Oil Company never directly employed either Earl W. Oglebay or David Z. Norton, Rockefeller greatly influenced their fortunes. Oglebay inherited his father's interests in a West Virginia ironworks and controlled the National Bank of West Virginia, an institution his grandfather founded. Relocating to Cleveland to pursue business expansion, Oglebay and Horace A. Tuttle established Tuttle, Oglebay & Company in 1884 to mine iron ore in Michigan and Wisconsin. Five years later, Oglebay secured sole control of the business when his partner died in a railroad accident. He also co-founded Cleveland's Central National Bank.

Norton began his career at the Commercial Bank of Cleveland as a clerk, progressing to the positions of messenger, assistant teller, assistant cashier and president. Politically well connected, Norton married Vassar-educated Mary Castle, the daughter of a former Cleveland mayor. In 1890, Rockefeller encouraged Norton to resign his banking position and join Oglebay in forming Oglebay, Norton & Company. Rockefeller provided financial assistance to the new business, partly to cost effectively mine iron ore from his holdings in Minnesota's Mesabi Iron Range, an enormous deposit that remains a major mining center. Oglebay Norton & Company managed the Rockefeller iron ore interests and acted as a sales agent. In 2008, the company moved from Cleveland to Pittsburgh as a result of a merger.

Oglebay resided on two Euclid Avenue properties, both previously owned by Cleveland industrialists. His first home, originally built by Ralph Harman in 1866, is the site of Cleveland State University's John Marshall College of Law. His second residence, previously the Stewart Chisholm mansion, is now the site of an office building.

Norton constructed two Euclid Avenue mansions. After thirteen years, he sold his English manor home (7503 Euclid Avenue) to build a grander

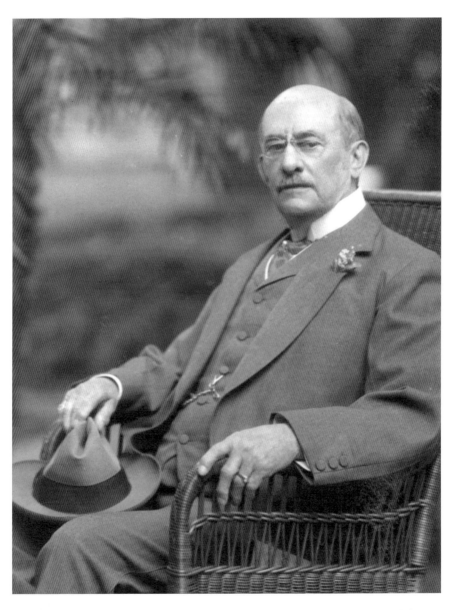

David Z. Norton, the second half of Oglebay Norton & Company, helped manage John Rockefeller's iron ore interests. *Courtesy of Cleveland State University, Cleveland Press Collection.*

Norton's Euclid Avenue home offered one of the wealthy neighborhood's eclectic décors. *Courtesy of Cleveland Public Library, Photographic Collection.*

mansion two blocks to the west. Later a private home and rooming house, Norton's first residence, demolished in 1947, made way for a Dorsel's diner, William's Drive-In Restaurant and Hot Sauce Barbecue. The site is now a facility for chronically homeless persons. Opened in 2011, the complex consists of seventy apartments, a computer lab, a community room and a shared garden.

Norton's second home (7301 Euclid Avenue), constructed in 1897, reflected his success with Oglebay, Norton & Company. In 1928, Norton died in this residence at the age of seventy-six, only twelve hours after the funeral of his wife of fifty-one years. The Norton family continued to live in the second mansion until 1937, after which the American Society for Metals occupied the site until 1958. The land currently houses a Famous Gyro George restaurant and adjoining parking lot.

THE CHISHOLM FAMILY'S HERITAGE: THREE GENERATIONS CONSTRUCT FOUR MAJESTIC MANSIONS

Born in Scotland, Henry Chisholm arrived in Cleveland at the age of twenty-eight in 1850. Seven years later, Chisholm unleashed his entrepreneurial instincts by investing in a steel mill. In 1863, Chisholm and four partners founded the Cleveland Rolling Mill Company, later the American Steel & Wire Company and, still later, a division of U.S. Steel.

In 1863, Chisholm purchased a six-year-old Tuscan villa mansion (653 Euclid Avenue), where he resided until his death in 1881. In 1893, the razing of the home to construct the still-existent New England Building (currently a Holiday Inn Express) ended the era of residential homes on Euclid Avenue between Public Square and East Ninth Street.

After his father's death, William Chisholm Sr. assumed leadership of the Cleveland Rolling Mill Company, along with another mill in Chicago, and resided in a stately home (2827 Euclid Avenue). The Cleveland Institute of Music, a colony of artists and writers, and the Cleveland Bible College later utilized the mansion. Razed in 1958, the land now contains an office building and a portion of the adjoining parking lot.

Stewart Henry Chisholm, another of Henry's sons, also labored as an executive with the Cleveland Rolling Mill and American Steel & Wire. After living in a Euclid Avenue mansion (3730 Euclid Avenue) from 1891 to 1908, Chisholm moved to another home (6407 Euclid Avenue). In 1912, Earl W. Oglebay purchased the earlier home, remaining there until 1925. Harry C. Collins, the final residential owner, moved out in 1932; later tenants included a law publishing company, a health club, a hospital, a restaurant, a variety club and an American Legion facility. A parking lot, and later an office building, followed the mansion's demolition. Chisholm's later address (6407 Euclid Avenue) is now dominated by a vacant building.

In 1895, William Chisholm Jr. (grandson of Henry) constructed a residence located at 3618 Euclid Avenue. William T. Corlett, MD, purchased this mansion in 1911, adding an annex for his medical office and children's room. The Elk's Club purchased the mansion and, in 1923, hosted orchestra leader Guy Lombardo's first U.S. performance. Following use as a restaurant, hospital and rooming house, the mansion gave way to a newly constructed 1965 motel, still existing through numerous changes of ownership.

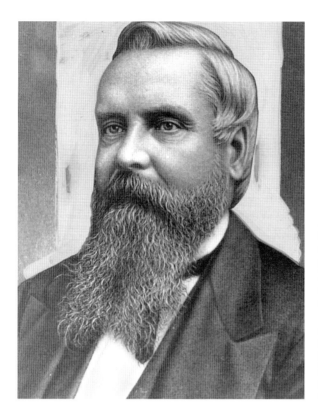

Left: Steel pioneer Henry Chisholm, and members of the next two generations of his family, resided on Millionaires' Row. *Courtesy of Cleveland State University, Cleveland Press Collection.*

Below: Chisholm amassed a fortune as founder of the Cleveland Rolling Mill Company. *Courtesy of Cleveland State University, Cleveland Press Collection.*

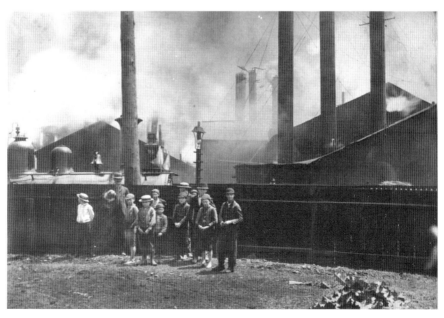

CHARLES SCHWEINFURTH:
THE MILLIONAIRES' MANSION DESIGNER

Many prominent national architects contributed to the magnificence of Millionaires' Row: Stanford White, George Post & Sons, Richard Morris Hunt and others. Forrest Coburn and Frank Barnum, a Cleveland-based architectural team, designed the greatest number of residences, at least twenty-two in total. Yet Charles Frederick Schweinfurth is most associated with creating Euclid Avenue's extraordinary visual image (especially his stately Romanesque revival homes).

Born in New York in 1856, Schweinfurth worked as an apprentice for his architect father and gained valuable experience as a bricklayer, stonecutter and carpenter. Schweinfurth established an architectural firm in Boston but relocated to Cleveland while designing the magnificent Sylvester Everett mansion. During a quarter century, Schweinfurth created eighteen residences spanning seventy-five blocks of Millionaires' Row.

YEAR	ADDRESS	CLIENT
1887	4111	Sylvester Everett
1888	6603	George Worthington
1889	2827	William Chisholm Sr.
1889	3307	George Pack
1889	6203	Ralph Cobb
1891	2525	Julius French/Harry Devereux
1892	8811	John Severance
1892	3608	William Boardman
1892	1521	Charles Parker
1893	7224	Samuel Haserot
1894	8415	Henry Hatch
1894	7407	Arnold Saunders
1895	7404	Dan Hanna

Architect Charles Schweinfurth created many of Euclid Avenue's finest residences. *Courtesy of Cleveland Public Library, Special Collections.*

YEAR	ADDRESS	CLIENT
1898	7111	Albert Withington
1898	7301	David Norton
1899	3411	Jacob Cox
1912	2605	Samuel Mather

Schweinfurth designed a home on East Seventy-fifth Street, just north of Euclid Avenue, for a New York client. When the customer failed to occupy the structure, Schweinfurth adopted it for his own residence. The fourteen-room sandstone home is still standing. Schweinfurth also designed the extraordinary Five Oaks mansion in Massillon for banker and industrialist James Walker McClymonds.

Not confining himself to residences, Schweinfurth designed Euclid Avenue's Trinity Cathedral, the Calvary Presbyterian Church near East Seventy-ninth Street and the downtown Union Club. Additionally, Schweinfurth created homes in the Magnolia–Wade Park district, the four stone bridges above Martin Luther King Boulevard and, following a fire, a renovated interior for the Old Stone Church.

Not always easy to work with because of his volatile temper, one of his most famous tirades occurred in 1915 while working on the interior of the Cuyahoga County Courthouse on Lakeside Avenue. Not satisfied with the workmanship, Schweinfurth destroyed a nearly completed gold-leaf ceiling. An irate workman struck the architect across the face with a wrench, permanently blinding him in one eye.

HANNA, OTIS AND POPE: FATHERS AND SONS CHOOSE DIFFERENT PATHS TO AFFLUENCE

Marcus Alonzo Hanna, Charles Augustus Otis Sr. and F. Alton Pope, each succeeding in his chosen field, offered their sons an opportunity to perpetuate the family's wealth by following in their paths. All three produced a son who resided on Millionaires' Row, although each offspring selected an avenue to wealth differing from his father's livelihood.

Dr. Leonard Hanna prospered as the owner of a grocery store. His son Marcus, who attended Cleveland's Central High School with classmate John D. Rockefeller, earned his wealth in the iron and coal industries, after which he successfully turned to politics. Daniel Hanna, Mark's son, became a partner in his father's M.A. Hanna mining company. But Dan embraced the newspaper business as his chief passion. He owned and actively published the *Cleveland Leader*, *Cleveland News* and *Sunday News-Leader*. His legacy includes constructing two still-existing downtown landmarks: the Leader Building (Superior Avenue) and the Hanna Theater and Building (East Fourteenth Street). Dan resided in

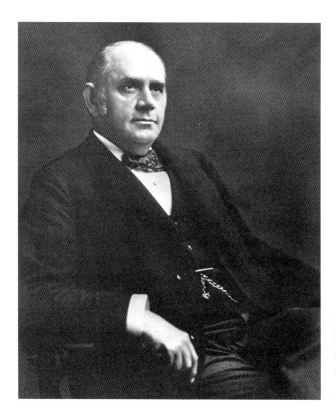

Mark Hanna accumulated wealth in iron and coal prior to entering the political arena. *Courtesy of Cleveland Public Library, Photographic Collection.*

a Millionaires' Row home (7404 Euclid Avenue) built in 1895 that later turned into the Art Colony Studio Building. After the building's demolition, a gas station and auto repair shop absorbed the site. Vacant for several decades, the land now supports an office building constructed in 2011.

Charles Augustus Otis Sr. founded the Otis Iron & Steel Company and served as a Democratic mayor of Cleveland. Jones & Laughlin, later absorbed by the LTV Company, purchased his steel company. His Victorian villa (3133 Euclid Avenue), built in 1872, would later be occupied by William B. Sanders, Otis's son-in-law, followed by the John Huntington Polytechnic Institute. In the 1950s, the B.F. Goodrich Chemical Company built an office building on the site that still remains.

Charles A. Otis Jr., choosing a career as an investment broker, is remembered as the first Clevelander to purchase a seat on the New York Stock Exchange. Otis held interests in the newspaper industry, owning the *Cleveland Leader* before selling it to Dan Hanna. He founded the Otis Terminal Warehouse Company, a wholesale food distributor, and presided

Daniel Hanna pursued the newspaper business as his chief business interest. *Courtesy of Cleveland Public Library, Photographic Collection.*

Charles A. Otis Sr. founded the Otis Iron & Steel Company. *Courtesy of Cleveland State University, Cleveland Press Collection.*

Charles A. Otis Jr. became the first Clevelander to purchase a seat on the New York Stock Exchange. *Courtesy of Cleveland Public Library, Photographic Collection.*

over William Edwards & Company, a forerunner to the Pick-N-Pay grocery chain later purchased by the Finast/Topps organization. The four-building Otis Terminal complex has been converted into 248 upscale apartments in the Warehouse District. Otis's Euclid Avenue mansion (3436 Euclid Avenue) is the site of an office building.

F. Alton Pope, a woolen goods manufacturer, earned awards at London's famous Great Exhibition at the Crystal Palace in 1851. He later founded a Cleveland woolen business, with his sons employed as partners. In 1869, Alfred Atmore Pope resigned from the family business to invest and work in the new Cleveland Malleable Iron Company; he rose to the position of president. The company produced castings for railroads, wagons, buggies and farm equipment. In 1895, Pope celebrated his wealth by constructing a fine home (3648 Euclid Avenue). Afterward, Pope retired to pursue life as a gentleman farmer in Connecticut. His former company, renamed the National Malleable & Steel Castings Company, opened plants in other cities and later merged with Cleveland-based Midland-Ross, which remained in existence until purchased by a New York private equity firm. His former Euclid Avenue residence is now an office building.

FROM MANSIONS TO CLASSROOMS:
THE CLEVELAND STATE UNIVERSITY NEIGHBORHOOD

Along with many affluent industrialists, Cleveland mayor Tom L. Johnson resided on Euclid Avenue in the neighborhood now dominated by Cleveland State University. After acquiring enormous wealth as a business owner in the transit and steel industries, Johnson transformed himself into a liberal politician, serving in the U.S. House of Representatives and as mayor of Cleveland. He championed the poor and oppressed while living in his mansion, situated just west of East Twenty-fourth Street; the home included an indoor ice-skating rink. A used car lot occupied the site for more than forty years prior to Cleveland State University's construction of a science building,

Charles W. Bingham, the son of hardware entrepreneur William Bingham, earned bachelor's and master's degrees from Yale. From 1881 until his death in 1929, he directed the Standard Tool Company, a subsidiary of his father's hardware business. Operating near West Ninth Street since its inception, the Bingham Company constructed a new wholesale warehouse in 1915. Although the Innerbelt Freeway claimed Bingham's Euclid Avenue residence, the warehouse now consists of 340 fashionable loft apartments.

Harry Kelsey Devereux owned the home just east of the Bingham residence. As a child, Archibald Willard used Harry as the model for the drummer boy in his famous *Spirit of '76* painting. The son of John Henry Devereux, a railroad executive, Harry competently continued in his father's chosen vocation. Enthralled with harness racing, Harry developed into an expert driver, winning many national prizes. He financed construction of Randall Racetrack and served as its first president. His mansion, built in 1889 and originally owned by Devereux's father-in-law, railroad baron Julius French, contained an eighty-two-foot frontage on Euclid Avenue with a depth of seven hundred feet to Chester Avenue. Razed in 1952, the Cleveland State University Physical Education Building now occupies part of the site.

Born into immense wealth, Samuel Mather accumulated even more riches by expanding his father's iron ore and coal mining business. Constructed on the site of railroad builder Jacob B. Perkins's former home, Mather's forty-three-room mansion included formal gardens and squash courts. The first floor contained a library, drawing room, dining room, billiard room, kitchen, pantries, den and office, along with a servants' hall. The second floor featured seven suites of rooms. The third floor comprised

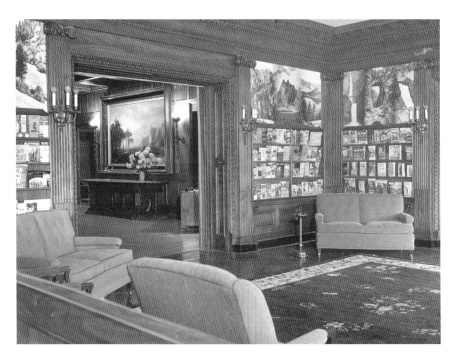

The Cleveland Automobile Club used the Mather mansion as its headquarters for many years. *Courtesy of Cleveland State University, Cleveland Press Collection.*

eight bedrooms and a sixty-five- by twenty-seven-foot formal ballroom, large enough to accommodate three hundred persons and highlighted by a sixteen-foot arched ceiling. Servants lived on the fourth floor. Mather died in 1931, the richest man in Ohio at the time. The Cleveland Institute of Music and the American Automobile Club used the mansion, which is now owned by Cleveland State University.

Industrialist Leonard Colton Hanna, brother of Mark Hanna, continued in the iron ore and coal businesses developed by Daniel Rhodes, Mark's father-in-law. Leonard also played second base for the Forest City Club, Cleveland's first professional baseball team. Designed by Stanford White in 1901, the Hanna home, located just east of the Mather mansion, housed the Cleveland Museum of Natural History for several decades until being replaced by the Innerbelt Freeway in 1957.

Charles Hickox, an industrialist and civic leader, lived next to Hanna in a French-inspired mansion built in 1855. The home remained in the family for seventy years. After Hickox's death in 1890, Harvey and Elizabeth Brown (Hickox's daughter) owned the residence. Frank

F. Hickox, son of Charles, lived in the mansion for many years, until his death in 1925. The Cleveland Museum of Natural History used the home for offices and laboratories until the residence turned into another victim of the Innerbelt Freeway.

THE APPLIED INDUSTRIAL TECHNOLOGIES SITE: MEMORIES OF SIX MANSIONS

Six millionaires (Daniel P. Eells, Anthony Carlin, Charles L. Pack, Peter M. Weddell, Jacob D. Cox Jr. and Andrew Squire) lived in mansions now occupied by the modernistic Applied Industrial Technologies headquarters, built in 1997 east of the Cleveland State University campus.

Daniel Parmelee Eells, a well-connected banker and financier, acquired interests in oil, iron, steel, cement, coke, gas and railroad businesses, as well as serving as a director of thirty-two companies. Eells used his Euclid Avenue mansion, built in 1876, to entertain immensely powerful political acquaintances. President-elect James A. Garfield and Ohio governor Charles Foster attended the wedding reception of Eells's daughter. President Benjamin Harrison visited the residence. In the mansion's library, Mark Hanna persuaded William McKinley to run for president. The home remained a private residence until acquired by Spencerian Business College in 1922. The Cleveland Bible College occupied the mansion from 1942 to 1957. Razing of the mansion in 1959 permitted construction of the Sahara Motel, later transformed into a YWCA.

The Hurlbut and Carlin residences illustrate first- and second-generation mansions constructed on the same site. Hinman B. Hurlbut, a lawyer, banker and railroad executive, built his family home in 1855. His extensive art collection, along with a substantial monetary gift, helped create the Cleveland Museum of Art. Anthony Carlin, the owner of a rivet company, constructed a new home immediately after the razing of Hurlbut's residence in 1911. Carlin's mansion incorporated a few out-of-the-ordinary architectural features, including a marble chapel next to his bedroom and a fishpond near the rear of a sunroom. A large wine cellar, built with nearly impenetrable masonry walls and steel doors, protected the valuable contents.

Charles Lathrop Pack managed the third generation of his family's lumber and salt business. Educated in Cleveland, Pack also studied

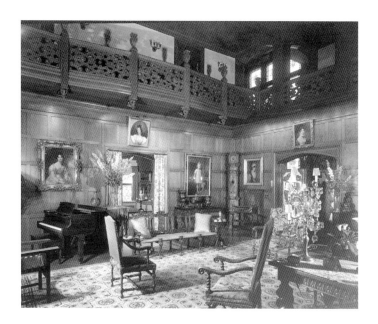

Banker and financier Daniel Eells entertained presidents in this Millionaires' Row residence. *Courtesy of Cleveland Public Library, Photographic Collection.*

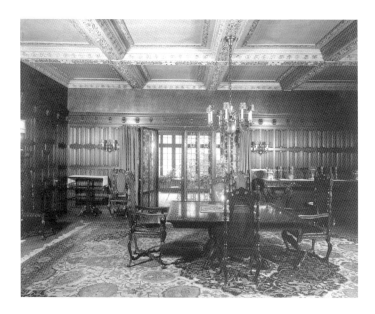

Another view of the Daniel Eells residence. *Courtesy of Cleveland Public Library, Photographic Collection.*

Anthony Carlin constructed a Euclid Avenue mansion in 1911. His son, the last link to the street's former wealth, moved from the avenue in 1950. *Courtesy of Cleveland State University, Cleveland Press Collection.*

forestry in Germany's Black Forest. President Theodore Roosevelt selected Pack to serve as a national conservation commissioner. Purported to be one of the five wealthiest men in America prior to World War I, Pack substantially enhanced his wealth by executing shrewd investments in timber, banking and real estate. In 1917, Pack moved from his Euclid Avenue residence following his election to president of the American Forestry Association. Vacant for many years, the Colonial Motor Hotel later occupied the site.

In 1832, wealthy dry goods merchant Peter M. Weddell constructed a residence later occupied by his son, Horace R. Weddell. In 1887, George W. Pack (father of Charles) purchased, remodeled and enlarged this home. Pack integrated a second house on the Weddell estate to create a combined residence of thirty rooms. Mary and Amos McNairy, the daughter and son-in-law of Pack, later lived in the original portion of the Weddell residence.

Andrew Squire, a founding partner of one of Cleveland's major law firms, lived in his mansion for more than forty years. *Courtesy of Cleveland Public Library, Photographic Collection.*

In 1928, the McNairy family constituted one of only four remaining families still living on Millionaires' Row. McNairy owned the home until 1942, after which it functioned as an apartment house. In 1953, demolition of the home allowed for the construction of a motel.

Jacob Dolson Cox Jr., the son of a Civil War general, Ohio governor and secretary of the interior, founded the Cleveland Twist Drill Company. Cox built his Euclid Avenue mansion in 1898; the family remained until moving to a nine-acre Bratenahl estate in 1939.

Andrew Squire, a founding partner of the Squire, Sanders & Dempsey law firm, lived in a twenty-seven-room Euclid Avenue mansion from 1895 until 1936. Before its demolition in 1967, tenants included the Red Cross, Sweden Manor Restaurant, Knights of Columbus and Salvation Army. An Al Koran Mosque replaced the mansion, itself razed in 1995.

EUCLID AVENUE JUST WEST OF EAST FORTIETH STREET: ARC LIGHTS, TELEGRAPHS AND CLUB PRIVILEGES

Charles Francis Brush, developer of the arc light, constructed one of Cleveland's most famous mansions on a seven-acre plot. The nearly forty-thousand-square-foot, three-story gray stone mansion contained seventeen rooms incorporating interiors finished with oak from England and rosewood from Japan. Louis Tiffany designed stained-glass windows, skylights and lighting fixtures. The basement contained Brush's private laboratory. A backyard windmill, fifty-six feet in diameter and supposedly the largest in the world, generated the first electricity used in a Cleveland home.

Rather than subjecting their dream palaces to almost certain urban decay, a few millionaires stipulated that the mansions must be demolished either upon their deaths or when no longer occupied by a family members. The forced demolition of Charles Brush's home paved the way for construction of the Cleveland Arena.

Anson Stager had already amassed twenty years' experience in the fledging telegraph business when he headed the government's Military Telegraph Department during the Civil War. A co-founder of the Western Union Telegram Company, Stager completed his mansion in 1866, subsequent to his transfer to Chicago, and never lived in the house. Thomas Sterling Beckwith, a leading dry goods merchant, purchased the ten-thousand-square-foot, fifteen-room, high–Victorian Gothic home. In 1900, Charles Brush, Beckwith's next-door neighbor, purchased the home to ensure the worthiness of his future neighbors. Thirteen years later, Brush sold the mansion to the University Club, which resided on the property for ninety years, until the organization disbanded in 2002. Purchased to accommodate the short-lived Euclid Avenue campus of Myers University, the mansion has been vacant for several years.

Jeptha H. Wade, creator of the nation's integrated telegraph network and president of Western Union, constructed two side-by-side mansions just west of East Fortieth Street—one for himself and the other for his son, Randall P. Wade. Both families moved into their Tuscan country villa homes in October 1866. The residences shared a common front driveway and backyard. The properties stretched north to Perkins Avenue (Chester Avenue did not yet exist). The lavish grounds contained a pond stocked with fish, stone walkways, shade trees, a pear orchard and a grape arbor. On

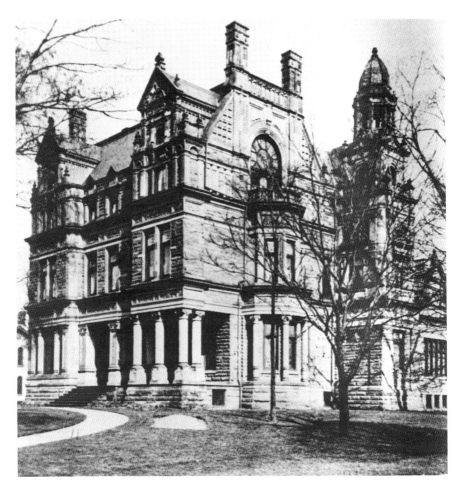

Charles Brush's nearly forty-thousand-square-foot residence became one of Euclid Avenue's most famous homes. *Courtesy of Cleveland State University, Cleveland Press Collection.*

August 16, 1870, Jeptha entertained President Ulysses S. Grant in his Euclid Avenue mansion. The president accepted gifts of flowers and choice grapes from Wade's gardens and arbor.

Exasperated by the clanging of bells at St. Paul's Church, a neighbor on the south side of Euclid Avenue, Jeptha paid the house of worship $1,500 to refrain from tolling its chimes. The bells never rang again during Wade's lifetime. At Wade's request, his house incurred demolition upon his death. Jeptha H. Wade Jr., son of Randall, assumed ownership of the remaining mansion after his father's death.

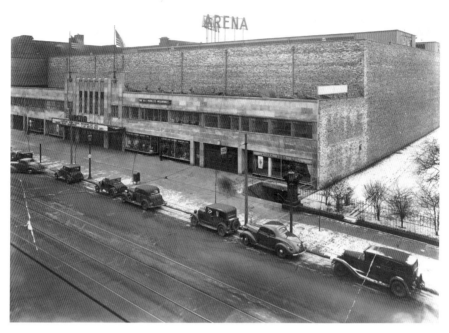

Above: The Cleveland Arena, shown here in 1940, replaced the Brush mansion. *Courtesy of Cleveland Public Library, Photographic Collection.*

Left: Jeptha H. Wade integrated the nation's telegraph network, creating the forerunner to Western Union. *Courtesy of Cleveland Public Library, Photographic Collection.*

Left: Banker Randall P. Wade, Jeptha's son, lived next door to his father. *Courtesy of Cleveland Public Library, Photographic Collection.*

Below: Randall P. Wade's Tuscan country villa sat near the intersection of East Fortieth Street. *Courtesy of Cleveland Public Library, Photographic Collection.*

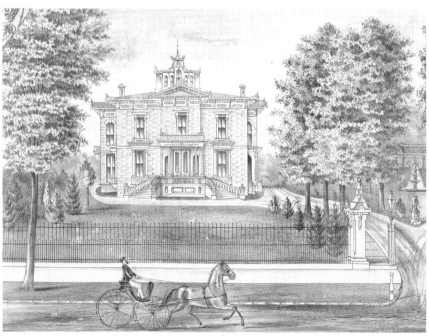

Escalating property taxes, the result of expanded commercial development, discouraged many millionaires from remaining on Euclid Avenue. Valuation of the remaining Wade home, set at $100,000 in 1900, had increased to $1 million by 1920. The family vacated the property when Jeptha H. Wade Jr. died in 1926 and razed the home in 1934. Following the Second World War, used car lots consumed the entire Euclid Avenue frontage of the former Wade mansions. The Campus Sportswear Company constructed a new facility, currently used by Cuyahoga County Community Services.

BEYOND EAST FORTIETH STREET:
EVERETT, STREATOR AND SEVERANCE

The horse and carriage enabled affluent Clevelanders to live away from the city's center but near enough for a reasonable commute to work. As a leisure pastime, carriage drives down Euclid Avenue provided an almost universal appeal among the wealthy. Avid horsemen, such as Samuel L. Mather and Harry K. Devereux, took great pleasure in their tours of the avenue. When riding in these open cars, men wore caps, tan dusters and goggles. Women covered their hats and faces with large chiffon scarves, securing the hats while protecting their faces from the wind and sun.

In 1904, only half of the country's population had seen an automobile, an invention perceived as a plaything for the rich. Reinforcing those perceptions, Euclid Avenue's well-to-do families avidly acquired the latest models. Samuel Mather incorporated an eight-car garage in his mansion. Enjoying jaunts in his Cleveland-manufactured Baker electric automobile, Mather simply abandoned the car in the street when its batteries wore down; his chauffeur would soon rescue him. In 1901, Dudley B. Wick spent $600 to purchase Cleveland's first Oldsmobile. The following year, Cleveland's mayor, Tom L. Johnson, bought the city's first two-cylinder Winton automobile. James J. Tracy Jr. enjoyed parading in his 1903 steam-powered White touring car, complete with a high-gloss aluminum red finish.

In 1883, Sylvester T. Everett, a banker with personal interests in iron ore and railroads, constructed a twenty-thousand-square-foot Romanesque revival mansion on the northeast corner of Euclid Avenue and East Fortieth Street. The home contained thirty-five principal rooms filling three floors,

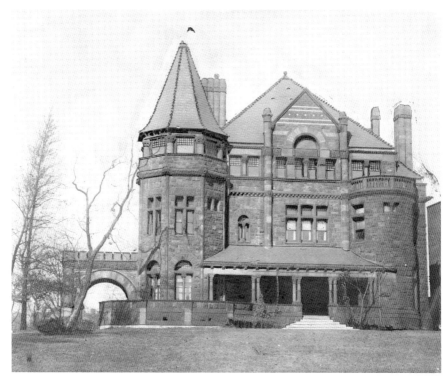

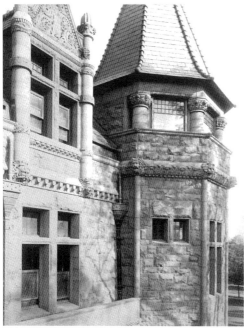

Above: Sylvester T. Everett constructed his twenty-thousand-square-foot mansion just east of East Fortieth Street. *Courtesy of Cleveland State University, Cleveland Press Collection.*

Left: Six U.S. presidents visited Everett in this Euclid Avenue mansion. *Courtesy of Cleveland Public Library, Special Collections.*

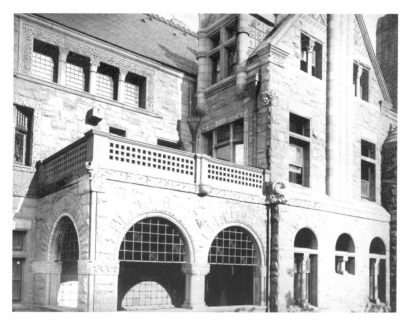

Following Everett's death, new owners turned the mansion into an apartment house. *Courtesy of Cleveland Public Library, Special Collections.*

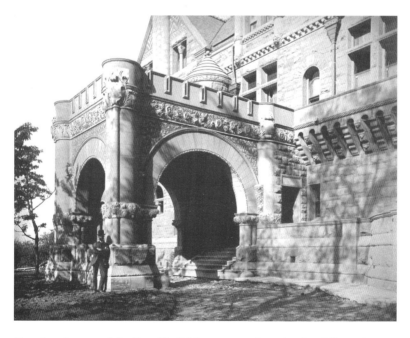

Once housing one of the finest Euclid Avenue mansions, the site of Everett's home is now a vacant lot. *Courtesy of Cleveland Public Library, Special Collections.*

forty fireplaces, fifteen bedrooms and twelve bathrooms. The Everett mansion hosted six presidents (Grant, Hayes, Harrison, McKinley, Taft and Harding), along with influential industrialists, including J.P. Morgan and Andrew Carnegie. Valued at $39,000 in 1890, Everett paid $1,100 in real estate taxes. Thirty years later, the home's appraisal soared to $604,000, generating a $14,000 tax liability. In 1922, the family sold the mansion. After twelve years as an apartment house, either used car or parking lots beautified the land for decades.

After his graduation from medical school in 1838, Dr. Worthy S. Streator relocated from New York to Aurora, Ohio; twelve years later, Streator moved to Cleveland. Introduced to the city's many opportunities for acquiring wealth, the doctor abandoned his medical practice to specialize in railroad development. Streator remodeled his old farmhouse (6903 Euclid Avenue), transforming the residence into a ten-thousand-square-foot country villa. He changed his focus to coal mining in 1866, founding the city of Streator, Illinois, in the process. The former doctor embarked on his fourth career by turning to politics, first serving as an Ohio state senator. President Rutherford B. Hayes appointed Streator the collector of internal revenue for the Northern District of Ohio, a position renewed by Presidents Garfield and Arthur. After conversion to a rooming house, a gas station replaced the demolished mansion. The land is currently a mostly vacant field interspersed with a few park benches and flowerpots.

Banker Solon Long Severance and his wife, Emily, lived in a Romanesque revival mansion in the 8800 block of Euclid Avenue. Solon and Emily journeyed with Samuel L. Clemens (Mark Twain) on his expedition to the Holy Land, which inspired Clemens's famous travel book, *The Innocents Abroad*. Their son, Western Reserve University professor Allen D. Severance, resided in the home after his parents' deaths. Beginning in 1924, the Huron Road Hospital and Ingleside Hospital used the mansion. The Cleveland Health Museum demolished the Severance home as part of an ill-conceived expansion. After failing almost immediately as a museum, the Cleveland Clinic Foundation purchased the relatively new building. Solon's nephew, industrialist John L. Severance, resided next door. John earned a fortune with investments in oil refining, salt and paint and varnish

WARNER AND SWASEY: BUSINESS PARTNERS AND EUCLID AVENUE NEIGHBORS

Worcester Reed Warner and Ambrose Swasey first met in 1866 as twenty-year-old apprentices employed by the New Hampshire–based Exeter Machine Works. The two moved to Pratt & Whitney Measurement Systems, a Connecticut company noted for machine tool manufacturing. In 1880, Warner and Swasey relocated to Cleveland, launching a business to manufacture machine tools, instruments and special machinery. Business partners for fifty years, the pair constructed side-by-side homes on Euclid Avenue, just west of East Seventy-ninth Street. Not settling for second-tier architects, the pair hired New York designer Richard Morris Hunt, who created George W. Vanderbilt's 250-room French Renaissance château, Biltmore; the New York Tribune Building; many Fifth Avenue mansions; and Case Western Reserve's Clark Hall. The

Worcester Warner and Ambrose Swasey established a business to produce machine tools, instruments and special machinery. The partners constructed side-by-side homes on Euclid Avenue, near East Seventy-ninth Street. *Courtesy of Cleveland Public Library, Photographic Collection.*

Swasey homesite, later a used car lot, is now a parking lot for Calvary Presbyterian Church. The True Holiness Temple (formerly the Second Church of Christ Science and then the Cleveland Playhouse) occupies the Warner home's former location.

The Millionaires' Racetrack

Did you know there was a very special event that happened on the avenue for thirty years, and yet most are totally unaware of it? The event took place between 1875 and 1905 and was known throughout the world as Euclid Avenue's famous sleigh races.

Euclid Avenue's millionaires engaged in competitive sleigh races during the last decades of the nineteenth century. Red flags, posted at East Ninth and East Fortieth Streets on Wednesday, Thursday, Friday and Saturday afternoons, halted all other vehicular travel on Euclid Avenue between these cross streets. The public didn't mind the inconvenience; crowds along Euclid Avenue numbered in the thousands as from fifty to eighty friendly rivals typically waited at the starting line. Ideal for racing, the paved sixty-foot-wide Euclid Avenue course contained no streetcar tracks. The city banned streetcars on this most prestigious portion of Millionaires' Row until 1915. The sleighs reached speeds of twenty-five to thirty miles per hour, requiring Cleveland officials to suspend Euclid Avenue's six-mile-per-hour speed limit during the contests.

Races took place starting on Euclid and Fortieth Streets and ended at our East Ninth Street, a bit over a mile away. The breed of horse of choice was a trotter. Cleveland, in fact, became the home of the trotting industry, as residents of the avenue demanded the world's best horses. Race days lasted six weeks, from November into December, and during this period took place every Wednesday, Thursday, Friday and Saturday afternoon. Thousands of people lined the avenue for the races, watching the famous residents at play. Favorite coats for the bystanders were made from buffalo skin and were available through any number of merchants throughout the city. Horses with bells and plumes added to the event as rivalries developed over the years. My, oh my, what a time this must have been!

Frequent racers included Euclid Avenue luminaries John D. Rockefeller, Jeptha H. Wade, Harry Devereux, Jacob B. Perkins, Charles Otis, Leonard Hanna, Julius French and Morris A. Bradley. Buffalo and fur lap robes

kept the dignitaries warm, while their faithful footmen supplied charcoal foot warmers. Wade possessed the finest cutter, a two-horse Russian sleigh festooned with flaming red plumes. Devereux organized his work to accommodate the races, usually working in his office until mid-afternoon prior to participating in the friendly rivalry with Kate Owen, his favorite mare. The millionaires' use of trotting horses helped develop Cleveland's reputation as an early center for the trotter racing industry.

MILLIONAIRES' ROW'S MOST INFAMOUS RESIDENT

Canadian-born Elizabeth Bigley never fit the lofty profile of a Millionaires' Row resident. Arrested for passing bad checks at the age of fourteen, Betty prepared for her role in the city's society by laboring as a clairvoyant, fortuneteller and madam of a brothel. Arriving in Cleveland using the name Lydia DeVere, she married a doctor, who, unable to pay her massive debts, divorced her after only one year of marriage. Calling herself Marie LaRose, she married her next husband, a Trumbull County farmer. After four years of cultivating the soil, she confessed to adultery and divorced her second husband.

A forgery conviction confined her to a Toledo jail for four years. Returning to Cleveland as Cassie Hoover, she met her third husband, Dr. Leroy Chadwick, a wealthy and highly respected widower who frequented a near–west side brothel, which she operated. The marriage elevated her from the house of ill repute to a mansion on Millionaires' Row, where Cassie Chadwick's creative talents attained new heights. Previously, Cassie had claimed to be the daughter of a British general, the widow of an earl and the niece of President Ulysses S. Grant. But her new charade developed into her most impressive act of deception.

During a visit to New York City, Cassie asked one of her husband's legal acquaintances to drive her to the home of Andrew Carnegie. Although she only visited Carnegie's housekeeper, Cassie conveniently dropped a $2 million promissory note, supposedly signed by Carnegie, in sight of her husband's associate. Swearing him to secrecy while eagerly anticipating his breach of trust, Cassie claimed the steel baron had fathered her as an illegitimate child, subsequently paying her large sums of money to help alleviate his guilt. Never known for her conservativeness, Cassie asserted that she would inherit $400 million upon Carnegie's death.

Left: Cassie Chadwick, an outlandish swindler, died in prison. *Courtesy of Cleveland State University, Cleveland Press Collection.*

Below: After marrying a doctor, Cassie Chadwick lived in this Euclid Avenue home. *Courtesy of Cleveland State University, Cleveland Press Collection.*

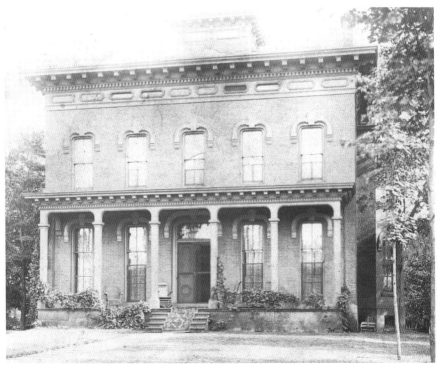

Cassie's spicy story was soon propagated throughout Cleveland's financial community. For eight years, the sham allowed her to secure loans, eventually totaling about $15 million. During this time, Cassie lived the luxurious lifestyle appropriate for her station as a Euclid Avenue resident. As her deception ultimately unraveled, Carnegie denied any knowledge of Cassie or her many aliases. Following his wife's arrest, Dr. Chadwick hurriedly arranged a European tour, but not before filing for divorce.

Andrew Carnegie attended her trial, curious to observe the woman who had successfully persuaded otherwise rational bankers to believe her preposterous fabrications. A jury found Cassie guilty of conspiracy against the U.S. government since some of the banks she had defrauded operated with federal charters. The judge fined her $70,000 and sentenced her to fourteen years in prison. Cassie died in confinement at the age of fifty. The site of the Chadwick residence, located near East Eighty-second Street, is now the home of the Liberty Hill Baptist Church (originally constructed as the Euclid Avenue Temple).

THE GOLF CONNECTION

I selected writing about Sam Mather, along with two other Euclid Avenue families—those of John D. Rockefeller and Francis E. Drury—because, oddly enough, there was a common thread that ran through each family. This common thread was golf, of all things. Mather, for his part, brought the game of golf to Cleveland. Mather's summer residence, known as Shoreby, situated in Bratenahl, Ohio, was located within walking distance of the club he helped build before the turn of the century. Later in life, all summer, every day, he played his favorite sport. Sam Mather died in 1932 at age eighty-four after a full and prosperous life, enjoying golf to the very end.

The second family I chose to write about is the John D. Rockefeller family. No introduction is necessary here. Many things about Rockefeller are already well known, so it is not my intent to go over these now. This will come later in the book. For now, I want to continue the common thread of our families: golf. John D., like Sam Mather, loved golf, and like Mather, he played every day of the summer at his East Cleveland estate, known as Forest Hills. Rockefeller's golf story has an interesting twist. It is one of my favorite stories.

A Stroll Down Millionaires' Row

John D. looked forward to retiring in his early fifties. Having worked since age sixteen, he began to feel a forty-year work career was enough. The flaw in Rockefeller's plan, though, was the federal government, which decided that the Standard Oil monopoly had to go. Thus, John D. had to begin the lengthy process of defending his actions, putting off retirement for a time. During this process, it is believed John D. acquired a disease known as alopecia areata, a rare disease where one loses every hair on his body. One of the many causes of this disease is a nervous condition that may lead to chemical imbalance in the body. John D. had plenty to be nervous about, as the feds were determined to stop the business practices of Standard Oil.

John D., having married his high school sweetheart, Laura Spellman, known as Cettie, enjoyed a great, lasting marriage. After some thirty-five years of marriage, Rockefeller, for some reason, began to have doubts about what Cettie really thought about him. I do not know what prompted this feeling, but the concerns appear to have been there. It would be natural to think John D. might just ask Cettie about his concerns. Aside from the doubts, their marriage was a loving and respectful one. One would think that John D., the richest and most successful man in the world, would have no problem discussing the issue with his wife.

It often occurs to me now, having been married thirty-five years, that all husbands and wives would benefit from engaging in a wonderful conversation about their shared partnership in developing family, friends and financial success. I must say, maybe there is something in our male makeup, for I, like John D., have not had this conversation with my dear Sue. I, like John D., will continue to impress my wife with my actions in hopes that this relationship remains strong and loving.

Well, now, we have a situation where John D. determined he would attempt to impress Cettie in a somewhat unusual manner. Oddly enough, he decided to impress her by learning to play golf for, you see, John D. built his marvelous course at Forest Hills for Cettie and her sister so they could play daily. John D., for whatever reason, did not initially play golf. His plan was to hire the pro at Sam Mather's club to teach him to play golf secretly for one year. Interestingly, in his mind, this was going to be the key to impressing Cettie. John D. attended the lessons at Forest Hills all summer early each morning—very early so his wife would be unaware of what he was up to. Rockefeller even hired a photographer to take a picture of his golf swing so he could study and improve. This became a serious business.

In 1913, at the age of seventy-four, Rockefeller still actively participated in golf outings.
Courtesy of Cleveland Public Library, Photographic Collection.

Left: Francis Drury's partnership with John D. Rockefeller resulted in Drury's company becoming the world's largest manufacturer of kerosene stoves. *Courtesy of Cleveland State University, Cleveland Press Collection.*

Below: Augusta Country Club, preamble to Augusta National Golf Club. *Courtesy of Library of Congress.*

The summer passed, and the time arrived for the big moment. Cettie and her sister Lute were getting ready for their early morning game when John D. strolled onto the course. His words, as I understand them, were to ask Cettie for her club, as he was going to show her how to truly play the game. It is said that Cettie and her sister, having played for several years, laughed so hard they had to sit to contain themselves. In their minds, of course, John D. had never touched a golf club before. How was he going to show them anything? John Rockefeller, remaining composed, confidently took a ball, put it on the tee and, in John D. fashion, hit it straight down the fairway. The women were speechless as John D. walked away with newfound confidence. As we might say today, mission accomplished. Rockefeller never again questioned Cettie's feelings for him.

The last of my three families is the Francis Edson Drury family. I will have a complete chapter later in this book, but for now, this will do. Drury, unlike Mather and Rockefeller, did not play a lot of golf, but his influence on the sport is unquestioned. What might this be?

Francis, over the years, developed a wonderful estate in Augusta, Georgia, home today to a rather famous golf course. Drury also, over the years, developed a strong relationship with the best amateur golfer to ever have played the game, one Bobby Jones. It is said that Francis supported Bobby Jones financially as he pursued his great career, even traveling with him to Europe. As Jones accomplished the famous Triple Crown, he became a great milestone in the golf world. When it came time for Jones to retire from active golf, his dream was to build a golf course—one on which the golfers of the world would compete. Jones did this with the financial help of Francis Edson Drury of Cleveland, Ohio. Today, the Drury name is on a plaque that hangs in the Augusta National Clubhouse. For you see, Drury, became a founding member of the Augusta National Golf Club.

MILLIONAIRES' ROW: DECLINE AND DEMISE

A few of Cleveland's elite constructed splendid Euclid Avenue mansions into the early twentieth century: Leonard C. Hanna (1904), Samuel Mather (1910), Anthony Carlin (1911) and Francis Drury (1912). But the magnificent residential community soon disappeared as commercial interests transformed Euclid Avenue into a mercantile thoroughfare.

In the 1920s, Millionaires' Row spiraled into a swift decline. Wealthy residents relocated to Cleveland's exclusive eastern suburbs, some of these areas consisting primarily of farmland when the exodus commenced. The automobile facilitated the transition from city to suburb, easily bridging the gap between Public Square and affluent eastern communities. In 1928, only four well-to-do families remained on the once splendid street, each living between East Thirty-second and East Thirty-eighth Streets. Alluring elm trees, previously lining the avenue, died from disease, pollution and neglect. Later owners converted former mansions into rooming houses, further accelerating the decline.

John Carlin (Anthony's son) and his family, the final remaining well-heeled link to Millionaires' Row, deserted the avenue in 1950. Unmistakably aware of the significance of their decision, the family sponsored a farewell party and dance attended by one hundred guests. The International Ladies Garment Workers Union and Community Guidance Center occupied the Carlin home prior to its demolition.

The survival of ten Millionaires' Row structures, between East Twenty-fourth and East Twenty-eighth Streets, ended in the 1950s. On the north side, the six consecutive stately mansions of Bingham, Devereux, Mather, Hanna, Hickox and Chisholm still endured as the decade began. By 1958, only the Mather mansion remained. Demolition of the Bingham and Devereux homes aided the later expansion of Cleveland State University.

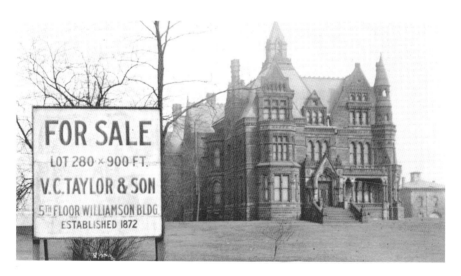

Andrews's impractical home, for sale in the early 1920s, garnered no takers except for the wrecking ball. *Courtesy of Cleveland State University, Cleveland Press Collection.*

The Hanna and Hickox residences supplied space for the Innerbelt Freeway, while an office building now occupies the Chisholm site.

On the south side, the Thomas Burnham and Alexander E. Brown homes stood opposite the Hanna and Hickox residences. In the 1930s, developers converted both residences into rooming houses. Razed in 1946, the Burnham mansion's location later supported a used car lot and hotel. The Innerbelt Freeway claimed both the hotel and the Brown residence. In 1957, demolition of the former residence of Rufus P. Ranney, an Ohio Supreme Court judge, facilitated construction of an office building. Finally, an old town house, once the home of Hathaway Brown School and a later hotel, gave way for construction of an office building.

By the 1960s, much of Euclid Avenue resembled an urban slum, full of vacant and decaying buildings, shoddy housing, used car lots, adult movie theaters and weed-covered fields filled with broken glass and other trash.

REMAINING REMNANTS OF THE GILDED AGE

Eight homes and a carriage house linger on Euclid Avenue, vestiges from the Millionaires' Row era. The Cleveland Clinic Foundation has meticulously restored the Francis Drury and Henry Windsor White residences. The Samuel Mather mansion and the Howe home, the latter on the south side of Euclid Avenue, have been similarly renovated by Cleveland State University. The currently vacant Stager-Beckwith mansion, the former home of the University Club, awaits a new owner.

In 1848, John Henry Devereux moved to Cleveland to obtain employment as a railroad construction engineer. During the Civil War, he assumed the position of superintendent of military railroads. In this capacity, Devereux brought desperately needed order to the Union railroad operations. Following the conflict, he returned to Cleveland to serve as president of three railroads. Built in 1873, his red brick, Second Empire home (3226 Euclid Avenue) remained in the family until the death of Devereux's wife in 1915. The old residence is sandwiched between an appendage to the Fine Arts Building and a commercial addition in the rear, both constructed in the 1920s.

The home of Luther Allen (7609 Euclid Avenue), a successful banker, railroad executive and industrialist, still exists, although concealed by a false

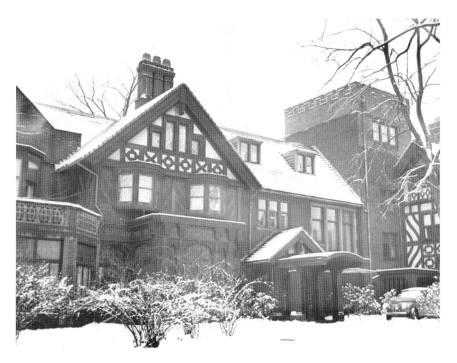

Drury's Euclid Avenue mansion, completed in 1912, still stands on the northwest corner of Euclid Avenue and East Eighty-seventh Street. *Courtesy of Cleveland State University, Cleveland Press Collection.*

front. Beginning in the mid-1920s, the home functioned as a rooming house, alcoholism treatment center, nursing home, insurance company office, savings and loan and multipurpose office building. In the early 1960s, the owners removed the front porch to facilitate the addition of a commercial façade.

J.J. Sullivan, president of Central National Bank, lived in a Millionaires' Row home (7218 Euclid Avenue) from 1897 to 1920. The residence, later occupied by a series of commercial tenants—the Grand Lodge of the Ohio Order of Sons of Italy, the Society of Heating and Ventilating Engineers, rooming house lodgers and the Coliseum Party Center—is still standing, although currently vacant.

In 1886, Morris A. Bradley, the son of shipbuilder Alva Bradley, constructed an English manor mansion at 7217 Euclid Avenue. Bradley occupied this home until moving to Shaker Heights in 1921. Converted to a rooming house, the Euclid Avenue residence eventually conceded its existence for a used car lot. But the adjoining carriage house, facing East Seventy-third Street, remains.

This Cleveland, Ohio, has quite the history. It is an extremely interesting and entertaining history that I believe still has much potential to make Clevelanders very proud of their city. Most people in Cleveland would like to build their pride in the city through our professional sports teams, but that just isn't happening for whatever reason. Maybe pride can be accomplished through knowing that, at one time, we were in the greatest city in the world. Understanding as part of this process what goes into greatness will further this cause, I believe. This understanding will arm one when confronted with those negative stereotypes that all Clevelanders run into from time to time. Each of us moving Cleveland forward will be an important ingredient. If we Clevelanders are negative about our city, how can we expect non-Clevelanders to be enthusiastic about what we have here? Each one of us should be a public relations enthusiast and publicly talk about the many great things of our great Cleveland, Ohio.

The above being said, let me alert you, my dear readers, to another important part of our history: our charitable nature. Cleveland by many, many standards is today considered one of the most charitable cities in the entire world. This is not really surprising, for most of the families who lived on Millionaires' Row made giving a big part of their lives. Volunteerism was a must and was taught by example to the many hundreds of children who were raised on Euclid Avenue. Much of this was a religious base, a philosophy of faith that did not look down on the accumulation of great wealth. Once earned, though, one had an obligation to give back to improve society in some fashion with monies earned. Mather, Rockefeller and Drury gave away huge sums to promote their favorite causes. They were the rule here in Cleveland, not the exception. Hospitals, museums, theaters and universities were created by the wealthy so people of lesser means could enjoy some of the great things in life. Obviously, the wealthy in so many respects felt firsthand the plight of the extremely poor. Mrs. Mather, Mrs. Rockefeller and Mrs. Drury worked hard to further education. The wealthy lived in a rather strict society with social standards that could make one's head hurt, but when it came to charity, all formality was forgotten.

Overall, Cleveland has all the ingredients to return to being one of the greatest cities in the entire world. My observation is that this will come from the people of Cleveland themselves. I am an old basketball coach now, but I do remember the great results pride can produce in improving performance. Pride in many cases allows one to actually beat an opponent of much greater talent. Am I optimistic here? You bet! I intend to do my part to make sure that in this case, history *does* repeat itself. I believe Clevelanders being proud of their city is key to a return to greatness.

2

JOHN D. ROCKEFELLER

THE PARADOX OF PROFIT

My coauthor, Alan Dutka, does a marvelous job in giving you, our readers, a historical background of each of my stories. Our thought was that with this knowledge one may find my stories more interesting and fascinating. Sometimes a raw history lesson is a necessity with endeavors of this type. The following chapter brings you up to speed on the John D. Rockefeller history, and I'll include a couple of stories about John D. that fascinated me as they gave me a closer look at Rockefeller the person.

John D. Rockefeller's life and business practices, full of contradictions and inconsistencies, remain an enigma to critics and supporters alike. He viewed business competition as a process of sacrificing weaker companies to create stronger organizations, a progression mimicking the laws of nature and, therefore, of God. Rockefeller crushed the businesses and lives of many competitors, but only after attempting to purchase their firms at a fair price. He offered stock in his company as compensation but paid cash if the seller preferred currency. Those accepting his stock earned financial rewards far in excess of their fondest dreams. Rockefeller also hired capable leaders from the absorbed companies to help manage his expanding empire.

Believing God bestowed on him the ability to earn money, Rockefeller reasoned he should acquire as much of it as possible but return the majority to improve the betterment of mankind. Although he earned millions of dollars, he gave away most of this wealth through philanthropic efforts. Consumers also benefited from Rockefeller's cutthroat business practices. His organization of the kerosene industry drastically reduced the price of

lighting oil. These lower prices directly assisted individuals in lower income brackets who could no longer afford the rising cost of whale oil.

THE FORMATIVE YEARS: MOLDING A FUTURE TYCOON

The second of William Avery and Eliza Davison Rockefeller's six children, John Davison Rockefeller spent his earliest years in New York State. Born on July 8, 1839, in Richford, his family moved to the farmlands of Moravia and Owego.

William owned farm property, sold lumber and marketed medicines. Functioning more as an itinerant peddler than traveling salesman, the "botanic physician" claimed his twenty-five-dollar treatment could cure cancer. William returned to his family infrequently but always with a substantial sum of cash to support his wife and children. William taught John the rules of creating promissory notes and other business papers and advised his son to use whatever means possible to benefit from every business deal. By William's reasoning, even cheating people would indirectly help them by increasing their skill in future dealings.

Eliza, a puritanical woman and devout Baptist, raised her children in an austere manner, but with love and affection. Through her influence, religion acted as a guiding force in Rockefeller's life. From his first paltry paycheck, he tithed 10 percent of his earnings to his Baptist church, later serving as a Sunday school teacher, trustee, clerk and occasional janitor.

By the age of twelve, Rockefeller had saved more than fifty dollars by working for neighbors, raising turkeys and digging potatoes. He loaned a local farmer most of his savings, charging 7 percent interest. When the farmer promptly paid his debt, Rockefeller concluded that wealth should act as his servant rather than he becoming a slave to money.

In 1853, the family moved to Strongsville, a farmland that grew into a southwestern suburb of Cleveland. Since no high school existed in the community, Rockefeller's father enrolled John in Cleveland's excellent Central High School, located near the intersection of Euclid Avenue and East Ninth Street. William secured a place for John in a boarding home, also on East Ninth Street, convenient to the high school and a nearby Baptist church. A few weeks before graduation, Rockefeller abandoned his high school studies to enroll in a ten-week business course at Folsom's Commercial College on

Nearly twenty years old in 1859, Rockefeller founded his first business, a commission business in Cleveland's Industrial Flats area. *Courtesy of Cleveland Public Library, Photographic Collection.*

Public Square. He studied single- and double-entry bookkeeping, penmanship, commercial history, mercantile customs and banking and exchange. John later married Laura Celestia Spelman, a high school classmate and daughter of a wealthy businessman.

John D. Rockefeller arrived in Cleveland, Ohio, at about age sixteen to attend the country's premier high school, Central High. It was Rockefeller's father, William Avery Rockefeller, who believed John D. needed a good education to make his way in life. On the surface, one could admire William Avery for his parenting skills and conclude he might have been the ideal dad. Surprise, William Avery Rockefeller was a dad all right, many times over, as most accounts shows that in actuality he was a bigamist, creating two families. John D. and his brothers and sisters were just half of the equation. As one might imagine, John D.'s father was absent from his son for long periods of time as he serviced his other family. William Avery, by all accounts, had a very checkered past; he earned his living as a medicine man selling potions he said would cure anything from stomach trouble to cancer. Some suggest he was even a horse thief at times. John D.'s initial experience in Cleveland, Ohio, was thus as a boarding student, as the family at this point lived in Strongsville, Ohio, which was two hours from Cleveland by horse.

William Avery Rockefeller taught his three sons to be completely independent and self-sufficient; which worked well for John D. later in life. John D., at about age eighteen, was given a project to complete. The elder Rockefeller decided it was time to move to the big city of Cleveland, Ohio. He called his son in one day and explained that it was time to build a family home in downtown Cleveland. He explained to his son that he had set up money in an account so that the home could be built during his

many absences. His father explained he would pay not one penny more than was in the dedicated account. Well, John D., an eighteen-year-old boy, took charge of the project and built a rather comfortable brick home for the family to live in. Eliza, John's mother, grew to love this house, and she enjoyed many years there raising a family without a husband, for William Avery would be gone for sometimes a year at a time. John D. built the family house under budget, as his sister Lucy commented on later. Lucy said, "John checked every detail, making sure all was perfect." Invoices that were not perfect were returned to the builder for correction. All were proud of John's effort, including, I believe, his father, who continuously drove home his point of self-reliance in the real world.

I believe the builder lost money when all was said and done. One has to ponder at this point in our story the skills and abilities of our own children at age eighteen. Most parents today feel their children are always ahead of the curve when it comes to maturity. You know the phrase "He (or she) is very mature for his age." Now, really, would any parent today do what William Avery allowed John D. to do—build the family home? I, for one, would have to answer in the negative.

Launching a Business Career: Working for Less than a Dollar a Day

On September 26, 1855, Hewitt & Tuttle, a wholesale commission merchant and produce shipping company, hired Rockefeller as an assistant bookkeeper. The sixteen-year-old commanded a beginning salary amounting to less than $1 per day, even though he toiled long hours in the company headquarters on Merwin Street. Four years later, demonstrating adeptness for arranging and calculating the cost of complex freight shipments involving travel by railroad, canal and lake, his annual salary had increased to $700. But John resigned, believing his talent and dedication should have commanded another $2 per week.

Nearly twenty years old in 1859, Rockefeller established his own commission business, dealing in grain, hay, meat and produce. In partnership with Maurice B. Clark, the two raised $4,000 in initial capital. Half of Rockefeller's contribution came from his father, who had planned on giving each of his children $1,000 on their twenty-first birthdays. Although William

The Standard Oil Company controlled many of its peripheral business functions, such as this delivery wagon shop, pictured in 1910. *Courtesy of Cleveland State University, Cleveland Press Collection.*

supplied his son with the money one year early, he charged John 10 percent interest in the interim period.

Clark handled much of the fieldwork while Rockefeller controlled office management, bookkeeping and relationships with bankers. But John also traveled, selling himself and his new company to perspective clients. The company's first-year sales of $450,000 translated into a profit of $4,400; profit nearly quadrupled to $17,000 the following year.

Although successful in the commission business, Rockefeller believed Cleveland's opportunities as a manufacturing center far outweighed its prospects as a focal point for agricultural commodities. Rockefeller correctly viewed the city as a major collector, manufacturer and shipper of industrial materials and products. Cleveland's competitive advantages included its geographical location, midway between the East Coast and Chicago; its accessibility to rail, river and lake transportation; and its supply of immigrant labor. In the early 1860s, Rockefeller envisioned an exceptional opportunity to penetrate this industrial business environment.

Above: John and Cettie Rockefeller. *Courtesy of Western Reserve Historical Society.*

Left: The interior of Rockefeller's home incorporated the quality workmanship prevalent on Euclid Avenue. *Courtesy of Cleveland State University, Cleveland Press Collection.*

John D. Rockefeller, by most accounts, bought a rather small mansion on Euclid Avenue, "Millionaires' Row," about 1868. Archives suggest he paid $40,000 for the home, a huge amount in that time. It is interesting to note that the status side of Euclid Avenue was the north side of the street. Most of the larger homes were on the north side, for these folks would have a view of Lake Erie from their back windows. John D., never one to dwell on status, was very comfortable on the south side of Euclid Avenue and East Fortieth Street. All of John and wife Cettie's children were born in this house; four children lived to adulthood, while little Alice died at an extremely young age.

The Rockefellers loved their home and all that it had to offer, as John D. could walk home for lunch from his offices on Cleveland's Public Square. A little note here: Rockefeller would take a short nap after lunch, which served to recharge him for the rest of rather busy days. John's house had only one problem: not enough land for his wonderful horses, some of the best in the country. Love of horses for John came from his father, who always purchased the best horses money could buy. John D. decided at one point to purchase the mansion next door to him so that he could build a wonderful new stable. Rather than destroying this mansion, Rockefeller decided to move this home, as it was to be used as a finishing school for the young women of Cleveland. Thus, he moved this house on greased logs up Fortieth Street about a half mile to Cleveland's Prospect Avenue, a street that runs parallel to Euclid Avenue, and set it down on a new foundation. John D. seemed once again able to accomplish the impossible. Wife Cettie oftentimes was quoted as suggesting there was almost nothing her husband could not do.

ENTERING THE OIL BUSINESS: HARMONY REPLACES CHAOS

The date of August 27, 1859, is firmly entrenched in the history of Titusville, Pennsylvania. Edwin Drake's oil strike set in motion a frantic new industry propelled by demand for a low-cost lighting source. Although in use for centuries, petroleum had previously been obtained only as it seeped from rocks or rose to the surface of streams. Drilling for oil represented a pristine business opportunity. In 1863, Rockefeller contributed his astute business savvy in establishing Andrews, Clark & Company, a partnership formed

The original Standard Oil refinery, on the banks of the Cuyahoga River, is depicted in 1870, the year Rockefeller founded the company. *Courtesy of Cleveland State University, Cleveland Press Collection.*

to refine oil. Samuel Andrews brought experience in the new field of oil refining. Maurice Clark and his two brothers provided needed capital.

The three Clark brothers soon opposed Rockefeller's strategy of expanding the business by incurring debt. When the trio threatened to dissolve the company, John consented but then repurchased the business for $72,500 at an auction. In addition to heavy borrowing, Rockefeller plowed the company's profits back into the business. The firm, renamed Rockefeller and Andrews, soon grew into Cleveland's largest refinery. In 1866, John and his brother William opened another Cleveland refinery. The following year, Henry M. Flagler entered the company as a partner. Flagler and Rockefeller had met years earlier when Rockefeller purchased grain for his commission house and Flagler sold grain as a merchant. Later a manufacturer of oil barrels, Flagler worked in an office in the same building as Rockefeller. The oil firm became Rockefeller, Andrews & Flagler.

Left: Rockefeller, at the age of thirty-five, had already gained a reputation as a cutthroat businessman. *Courtesy of Cleveland State University, Cleveland Press Collection.*

Below: The Standard Oil refinery on the Cuyahoga River displays a more sophisticated look in 1910. *Courtesy of Cleveland State University, Cleveland Press Collection.*

On January 10, 1870, John Rockefeller, William Rockefeller, Henry M. Flagler, Samuel Andrews and Steven Harkness (a new partner) created the Standard Oil Company. Harkness, the uncle of Flagler's wife, functioned as a silent partner, never assuming an active role in the business. All five partners, destined to become millionaires, rose from modest backgrounds. Rockefeller, beginning at the age of thirty, masterminded the company's future.

Standard Oil, controlling about 10 percent of the oil business at the time of its formation, paid a 40 percent dividend after its first year of operation. Rockefeller's company grew into one of the largest shippers of oil and kerosene in the country. After purchasing most of Cleveland's competing refineries, the company acquired additional refineries in New York, Pennsylvania and West Virginia. From the beginning, Standard Oil engaged in creative cutthroat practices. One scheme involved purchasing all the components required to manufacture barrels, thus hampering competitors from shipping their product. Because of its large volume, the company demanded and received refunds on railroad rates, effectively leveling a tax on its smaller competitors.

My coauthor, Alan Dutka, has given you a great insight into the partnership of John D. Rockefeller and Samuel Andrews. The following somewhat repeats Alan's version of this relationship. My version, although very similar, has a few different points that I thought you, my reader, might enjoy.

John D. Rockefeller, in his climb to success, had partners in the Standard Oil Company, known as "The Standard" in many circles. One such partner was a character by the name of Samuel Andrews. Andrews was from England and was a self-taught chemist, a key man in the refining of crude oil into kerosene and the making of so many other products that Standard Oil got into.

Sam Andrews, as a founding member of Standard Oil, owned a large amount of stock in the company. As such, he loved the dividend checks he received throughout the year. This situation made Andrews a very wealthy man. Well, John D. Rockefeller, in his quest to control the oil industry, at one point drastically cut paid dividends; he now used this money to grow The Standard by reinvesting and buying other refineries.

As mentioned earlier, Samuel Andrews's anger toward Rockefeller grew to a boiling point. At a board of directors meeting early on, Andrews challenged Rockefeller by suggesting that if Rockefeller gave him $1 million for his stock, he would leave the company. Now, Samuel had no interest of seeing this actually happen. By most accounts, it was

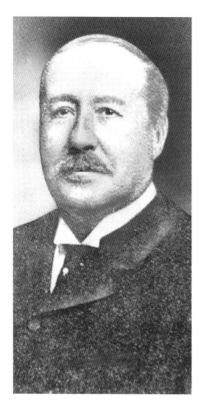

Samuel Andrews, a former investor in Standard Oil, constructed one of the most elaborate homes ever built on Euclid Avenue. *Courtesy of Cleveland State University, Cleveland Press Collection.*

meant to change John D.'s mind on the dividend issue. At this point, Samuel realized that Rockefeller was not one to reckon with. Andrews, in his bluff, also felt that John D. could never raise that much cash. Several days after the meeting, Rockefeller put a check on Andrews's desk for $1 million, buying back Andrews's stock. Samuel Andrews, his bluff being called, accepted the check, as he felt he surely got the better of Rockefeller in this instance. At this point, a note is in order. Many years after this event, it was said that two of the other founding members of The Standard—namely Henry Flagler and Stephen Harkness—were worth over $250 million due to their Standard Oil stock. Thus, our character, Samuel Andrews, left a good bit of money on the table.

Samuel Andrews, with $1 million in hand, now had a mission: to build the largest, most prestigious home ever built on Millionaires' Row. To begin the process, Andrews purchased over five acres of land on the north side of Euclid Avenue around Euclid and East Thirtieth Streets. Planning for the house began about 1880, and construction took place between 1882 and 1884. The Andrews home was extremely modern for the time, containing one of the first elevators on The Row. Being from England, Sam Andrews and his wife dreamed of entertaining Queen Victoria, so they had built a solid, black ivory bedroom for the upcoming occasion. I should note that the queen never made this visit. When complete, the Andrews house cost $1 million, a now familiar sum. The home, in total, was over forty thousand square feet, as Andrews's goal was to upstage a rather small mansion on the avenue owned by his now former partner John D. Rockefeller. Most homes on Euclid Avenue had house staff of around eight to twelve servants. The Andrews house required a staff of one hundred to service this huge palace.

The Andrews home did not work out as planned. No visit from the queen and an inability to maintain the huge home and the staff it needed caused the Andrews family to vacate what became known as "Andrews's Folly" after only a couple years of residency. While vacant, two movies were filmed in the mansion. Samuel's son lived in the home years later but found the place unmanageable. Vacant for many years, this Millionaires' Row home was torn down while beautiful furniture and rugs lay rotting inside.

Two events in the 1870s, both involving the Pennsylvania Railroad, tarnished the reputation of Rockefeller and Standard Oil. In 1871, the railroad attempted to unite refineries and oil-carrying railroads. The railroads expected to benefit by eliminating their disastrous price-cutting policies and guaranteeing their supply of shipments, while refineries would still receive substantial rebates. The railroad proposed adding a penalty to every barrel of oil shipped by a non-participating company, which included the smaller, independent companies. Part of this extra cost would be divided among the member refiners. The smaller owners successfully boycotted refiners and railroads supporting the scheme, while the State of Pennsylvania outlawed the plan. Although the railroads soon discarded the idea, the ensuing publicity introduced the formerly unknown Rockefeller to the general public in a very negative context. The episode helped permanently tarnish his reputation and inspire an upsurge of muckraking journalists.

Six years later, Standard Oil planned to build pipelines to transport oil. Viewing the action as an infringement on its territory, the Pennsylvania Railroad retaliated by forming a subsidiary to purchase or construct oil refineries and pipelines. Standard Oil countered by using other railroads to haul its oil, creating price wars within the railroad industry. Rockefeller prevailed as the railroad sold all its oil interests to Standard Oil. But the State of Pennsylvania, charging Rockefeller with monopolizing oil trade, started an avalanche of similar court proceedings in other states. John Rockefeller's business practices developed into a national issue.

THE STANDARD OIL COMPANY: AMERICA'S GREATEST MONOPOLY

By 1879, Standard Oil refined 90 percent of America's oil. The company developed its own barrel-making plants, reducing the cost of containers

from $3.00 to less than $1.50. Rockefeller purchased a forest to obtain inexpensive wood, further reducing the expense of the barrels. Standard Oil purchased tank cars, ships, docking facilities, depots, hauling services and warehouses. The company manufactured lubricating oil and sulfuric acid and experimented with the use of gasoline, a waste product in the refining process, as a source of fuel. Standard Oil developed or owned more than three hundred oil-based products, including paint, tar, Vaseline petroleum jelly and chewing gum. In the early 1880s, Rockefeller began selling certificates backed by oil stored in his pipelines. Speculators purchased and resold these certificates, in the process creating the oil futures market.

State legislatures often hindered the operation of a company incorporated in another state. Rockefeller and his partners consequently owned numerous corporations conducting business in only one state. To alleviate this cumbersome management structure, Rockefeller formed the Standard Oil Trust, the first of America's great corporate trusts. Rockefeller and eight other trustees managed the forty-one companies composing the trust. In 1892, the Ohio Supreme Court dissolved the trust, prompting Rockefeller to create twenty smaller businesses. He then reorganized Standard Oil of New Jersey, one of these new firms, as a holding company, essentially re-creating the trust. The U.S. Supreme Court disallowed this business structure in 1911.

By 1904, the invention of the light bulb had eroded kerosene sales, but demand for gasoline soared with the introduction of the automobile. Standard Oil had established a distribution system reaching 80 percent of America's towns. The company attempted to force all grocery and hardware stores selling kerosene and lubricants to carry only Standard Oil products. These aggressive procedures irritated the general public, increasing Standard Oil's vulnerability to political attack.

Life after Retirement: Forty Years of Philanthropy

Rockefeller retired in 1897, but his accumulation of wealth continued. The oil magnate owned land in the Minnesota iron range, along with a railroad and huge ore-carrying lake steamers to transport the iron ore. In 1901, Rockefeller sold this entire business to J.P. Morgan for $80 million, netting an estimated profit of about $50 million. The U.S. Steel Corporation absorbed these properties.

Left: John D. Rockefeller's burial place is marked by this obelisk in Cleveland's Lakeview Cemetery. *Courtesy of Cleveland State University, Cleveland Press Collection.*

Below: This mansion represents the downfall of Cleveland's Millionaires' Row, 1930s. Sadly, four generations and the row's heyday were over. *Courtesy of Cleveland Public Library, Photographic Collection.*

Spending the last forty years of his life in retirement, Rockefeller concentrated on philanthropic activities. His practical approach led to the creation of the conditional grant, whereby gifts became contingent on the involvement and contributions of others.

Rockefeller contributed more than $80 million to support the University of Chicago. He provided major funding for Spelman College, an institution created to educate African American women. Rockefeller also donated money to Yale, Harvard, Columbia, Brown, Bryn Mawr, Wellesley, Vassar and Denison Universities. His General Education Board promoted education at all levels throughout the country.

The Rockefeller Institute for Medical Research (later Rockefeller University) discovered serums to combat pneumonia, contributed to advances in experimental physiology and surgery and provided important research to cure infantile paralysis. The Rockefeller Sanitary Commission helped eradicate hookworm disease, while the Rockefeller Foundation focused on public health, medical training and the arts.

On May 23, 1937, Rockefeller died of arteriosclerosis as he approached his ninety-eighth birthday. The estate of the supposed billionaire contained a relatively modest $26,410,837. The vast majority of his earnings had already been given to philanthropic causes.

It is extremely interesting to me that, to my knowledge, most people in the United States and most in Cleveland, Ohio, do not know that Cleveland was Rockefeller's home. His fortune for the most part was made here in Cleveland. Rockefeller's money is still around today, now owned by fourth- and fifth-generation Clevelanders. Rockefeller and his wife, Cettie, are buried here in our Lakeview Cemetery. In all that you may have heard about John D., a point of interest you might not be aware of is that he loved to eat apples. As a youngster in Cleveland until old age, apples were always on the bedroom windowsill of his many residences. He was a physical fitness nut, spending hours riding his bicycle, ice skating and walking, much of this done at his Forest Hills estate of some seven hundred acres, located in both East Cleveland and Cleveland Heights. In later years, Rockefeller would ride his bike from golf shot to golf shot at his Forest Hills golf course. John D. Rockefeller loved all forms of nature. He loved to move big trees on his estate from one location to another. Each time this was done, he was very proud of the end result. Moving things seemed to be in his blood.

John D. Rockefeller played a large part in making Cleveland, Ohio, the wealthiest city in the world in 1885. Clevelanders should point with pride to Rockefeller and what he meant to our city. One, in reading about

Rockefeller, sees a character of mostly good. Though not perfect, John D. was a force, a force that moved society forward in a positive fashion. Some of the things John D. did could be questioned when he did them, but history is a strange animal sometimes. When one looks back from today's perspective, Rockefeller was ahead of his time. Thus, his conduct takes on a different meaning when looking at it through today's eyes. The charity aspect of the Rockefeller family would be enough by itself to elevate this man to a status of greatness. And by the way, the charity all began here in Cleveland, Ohio. One of my many daydreams is built around spending a week with John D. Rockefeller sometime in the 1920s, as it was during this time period that he finally began to talk about his life and its accomplishments. Well, daydreams come and go. They are still great fun and, I believe, add a nice touch of spice to life.

John D. Rockefeller Jr. continued the family's charitable legacy by guiding the restoration of Virginia's Colonial Williamsburg, building Rockefeller Center in New York and donating the land for the United Nations headquarters. His wife founded the Museum of Modern Art.

Nelson A. Rockefeller, grandson of John D., served four terms as governor of New York and as vice president under Gerald Ford. David Rockefeller, another grandson, headed Chase Manhattan Bank for more than twenty years. Voters in Arkansas elected Winthrop Rockefeller, a third grandson, as governor of the state. Great-grandson John D. "Jay" Rockefeller IV served as a West Virginia governor and senator. Winthrop Paul Rockefeller, another great-grandson, worked for ten years as lieutenant governor of Arkansas.

3

THE MANSIONS OF WICKLIFFE

NORTHEAST OHIO'S MARVELOUS MELODRAMA

Near the turn of the twentieth century, more than a few wealthy Cleveland industrialists constructed impressive mansions in Wickliffe, a suburban community fourteen miles northeast of the central city. The intertwinement among three of these affluent Wickliffe families fashions an amazing adventure beginning on Millionaires' Row in Cleveland, extending to Wickliffe and stretching to New York, London and Paris before concluding in northeast Ohio's Hunting Valley. The factual saga of the Frank Rockefeller, James Corrigan and Price McKinney families, which comprises incredible personal tragedy, a scandalous marriage, business intrigue and interactions with royalty, rivals the escapades of the most convoluted fictional melodrama. Beginning in the Gilded Age, the plot continues through World War II.

FRANK ROCKEFELLER: THE WAYWARD BROTHER

Frank Rockefeller never emulated his older brother's fame and fortune, a task few people could have accomplished. In 1870, Frank briefly competed with his brother's growing oil empire when he married the daughter of William Scofield, an industrialist who also owned oil refineries. Two years later, John D. ended the short-lived rivalry by absorbing Scofield's companies. Frank next invested in a Lake Erie shipping concern but

bungled a valuable Standard Oil contract. John D. eventually purchased his brother's interests in that enterprise. Frank participated in the management of another refinery founded by his father-in-law. After the company failed, Frank worked briefly as a stockbroker but soon accepted a vice-president position in Standard Oil. Ineffectual in this vocation, Frank remained in Cleveland, isolated from the company's mainstream activities, when Standard Oil relocated to New York.

Rockefeller next attempted to revive a failing ironworks in Columbus. Elected president because of his large monetary investment, he presided over a firm that dramatically returned to prosperity. But Samuel Prescott Bush, another influential company executive, orchestrated the financial turnaround. In 1908, Frank retired from the business, placing Bush in charge of the enterprise. Bush's descendants include George H.W. Bush, his grandson, and George W. Bush, his great-grandson.

Frank developed a partnership with his Wickliffe neighbor, Captain James Corrigan, a boyhood friend and business associate of John D. Rockefeller. The pair persuaded Frank's wealthy brother to lend them a substantial sum of money to purchase an iron mining company. Friction arose among the three businessmen because of Frank and James's frequent appeals for more of John's money. As the business wavered, John loaned the company sizeable sums of money, eventually demanding part of the Standard Oil stock Corrigan owned as collateral. John learned that Corrigan had also borrowed funds from a Cleveland bank, offering his remaining shares in Standard Oil as security. Rockefeller assumed this loan, thus securing an interest in all of Corrigan's Standard Oil holdings. In 1895, as the business continued to deteriorate, John forced his former friend to sell him all his Standard Oil stock.

Encouraged by Judge Stevenson Burke, a former Cleveland lawyer, Corrigan sued John Rockefeller for misrepresenting the price of the Standard Oil stock at the time John reacquired it. After a panel of arbitrators ruled in Rockefeller's favor, Corrigan and Burke pursued the lawsuit until it reached the Ohio Supreme Court, which once again sided with John Rockefeller.

These events created, in Frank's mind, a vision of his brother as a callous monster, although Frank still asked for and obtained personal loans from John. He spoke disparagingly about John to the news media, deserted the family church and never again spoke to his brother. Even during this period of hostility, John twice rescued Frank from personal bankruptcy, allowing him to retain a generous director's salary at Standard Oil. On his deathbed, Frank continued to denounce his brother. Following Frank's death, John paid all of his outstanding debts.

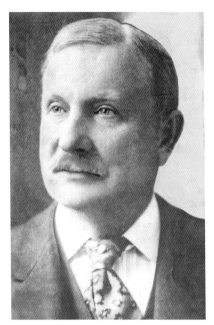

Left: Frank Rockefeller's bitterness increased as he engaged in business dealings with his more successful brother. *Courtesy of Cleveland State University, Cleveland Press Collection.*

Below: Home of Captain Corrigan, partner to Frank Rockefeller. *Courtesy of Cleveland Public Library, Photographic Collection.*

CAPTAIN JAMES CORRIGAN: COPING WITH CATASTROPHE

More than merely an owner of oil refineries, James Corrigan invented processes for efficiently manufacturing mineral and machine oil. In 1883, James sold his business to John D. Rockefeller, receiving three thousand shares of Standard Oil stock in exchange. Similar to most of Rockefeller's associates, Corrigan became wealthy almost instantaneously; he eventually entered Cleveland's privileged society by moving from East Fifty-fifth Street to Millionaires' Row on Euclid Avenue. Corrigan also purchased a four-hundred-acre Wickliffe farm, across from the Frank Rockefeller estate, which he named Nagirroc (Corrigan spelled backward).

Following his exit from oil refining, Corrigan invested in iron mines near Lake Superior. He co-founded Dallibra, Corrigan & Company, predecessor to Corrigan, Ives and Company. The management expertise of Price McKinney, a new partner, revived the company after it plummeted into receivership in 1893. The company's financial rebirth inspired a new name: Corrigan, McKinney & Company.

Corrigan purchased numerous schooners and steamers for his business enterprises. He also passionately enjoyed sailing as a recreation. In 1899, he acquired a pleasure yacht named *Idler*. The following summer, James, his brother John and members of their families embarked on a weeklong sailing and fishing outing in the Great Lakes' picturesque St. Clair Flats region.

Nearing the conclusion of the trip, the Corrigan brothers both departed the excursion. James traveled to Cleveland by rail to consult his doctor about an ear problem, while John attended a business meeting in Buffalo. Mrs. Edward Gilbert, John's daughter, accompanied her uncle back to Cleveland, a decision that most likely saved her life. Had the party remained intact, the horror of July 7, 1900, would never have occurred. Both experienced sailors, the brothers would have correctly navigated the yacht through the turmoil of a violent Lake Erie gale.

Almost in sight of Cleveland, a storm generating sixty-mile-per-hour winds struck the vessel. The terror-stricken families refused to leave their downstairs cabin, ignoring the warnings of C.H. Holmes, captain of the yacht, who asked them to come on deck. The yacht keeled on its side, sinking in a few minutes. Mrs. James Corrigan (age forty-eight), two of her three daughters (ages twenty-two and twenty), an infant granddaughter and a daughter of John Corrigan (an eighteen-year-old Vassar college student) drowned as they remained trapped in their downstairs compartment. Mrs.

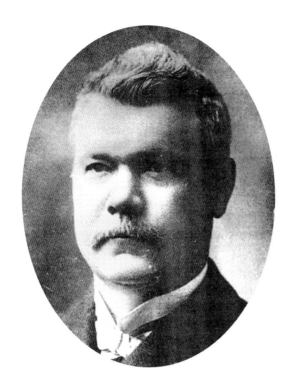

Left: Captain James Corrigan, founder of Corrigan, McKinney & Company. *Courtesy of Western Reserve Historical Society.*

Below: Corrigan, McKinney & Company, shown here in 1924, became an integral part of a twenty-year-drama spanning two continents. *Courtesy of Cleveland Public Library, Photographic Collection.*

John Corrigan, the only passenger escaping death, clung in the water to a deck couch until rescuers arrived. Along with Mrs. John Corrigan, only fifteen-year-old Ida May Corrigan remained on deck, but she still suffered a tragic death. Desperately clinging to the yacht's side, the towering waves washed her into Lake Erie. None of the crew died. The Corrigan brothers believed the ship captain's carelessness caused the capsizing. Although later exonerated, police initially arrested Captain Holmes, charging him with manslaughter.

In 1908, James Corrigan died of appendicitis, but not before inadvertently setting in motion a sensational set of personal and business scandals whose repercussions continued for decades.

PRICE McKINNEY: A FRIENDSHIP TURNS BITTER

Price McKinney's success in reversing the financial downfall of James Corrigan's iron and steel company allowed him to purchase a Millionaires' Row home and Ridgemere Farm, a Wickliffe estate located on Euclid Avenue at Bishop Road. McKinney judiciously directed the company, now renamed the Corrigan-McKinney Steel Company, and married the niece of Judge Stevenson Burke. Climbing in the city's social circles, McKinney attended important luncheons and dinners at the Union Club, owned box seats at the socially important Glenville racetrack and raised hunting horses in Wickliffe. In 1913, McKinney attracted the attention of New York society by becoming the largest purchaser at a Madison Square Garden horse auction, spending $125,000.

As a trusted friend of James Corrigan, McKinney assumed a personal responsibility that significantly contributed to his death. Corrigan's son, James Jr. (commonly referred to as Playboy Jimmy), handled his adult life as an irresponsible playboy. His most noteworthy accomplishments included membership in four country clubs and ownership of racehorses and polo ponies. Disapproving of his son's lifestyle, James initially removed Jimmy (his only heir) from his future inheritance. But McKinney convinced James to appoint him as the guardian of Jimmy's inheritance, promising he would not provide Jimmy with funds until he reached the age of forty and demonstrated he had gained the maturity to handle the wealth. At the time of his father's death, Jimmy received only $15,000. Jimmy gained

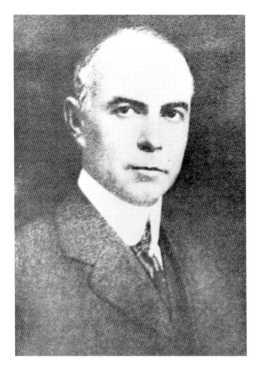

Price McKinney's expertise helped revive James Corrigan's struggling steel company. *Courtesy of Cleveland State University, Cleveland Press Collection.*

James Corrigan, Captain Corrigan's son, was known as Playboy Jimmy. *Courtesy of Cleveland Public Library, Photographic Collection.*

control of his inheritance only after a bitter court battle. The once-cordial relationship between Jimmy and McKinney soured, eventually leading to personal tragedy.

LAURA MAE CORRIGAN: FROM FORTUNE HUNTER TO ANGEL

Born in 1879, Laura Mae Whitlock grew up in Waupaca, Wisconsin, fantasizing she would make acquaintances with all the world's kings and queens. The daughter of a handyman, her childhood dream seemed relegated to creating make-believe elegant rings from cigar bands. Yet through a combination of hard work and luck, Laura Mae did socialize with most of the world's major royalty. Throughout her life, she demonstrated an uncanny ability to be in the correct place at the appropriate time, surrounding herself with the proper people.

Reaching adulthood and relocating to Chicago, Laura Mae labored as a waitress at Chicago's Hotel Blackstone on Michigan Avenue. She may also have worked as a telephone operator and cigar store clerk. Laura Mae convinced a Chicago newspaper to hire her as a society reporter. In 1907, she visited Cleveland to interview James Corrigan for her social column. A brief friendship developed in which Laura Mae spent time in Corrigan's Wickliffe mansion, but his death ended the relationship. At the funeral, Laura Mae met Jimmy, the family's estranged playboy.

Laura Mae lost her job as a reporter but married Dr. Duncan R. MacMartin, the Hotel Blackstone's house physician. Although not wealthy, the couple mingled with many socially prominent people, allowing Laura Mae to observe the life she sought for herself. In 1913, the pair even attended a party given by Jimmy Corrigan. Jimmy had just reinforced his playboy image by refusing to marry a Pittsburgh woman who successfully sued him for breach of promise. A passionate spark ignited between Laura Mae and Jimmy; she became his mistress while they arranged the details of her divorce. Married in 1916, Jimmy presented his new bride with a $15,000 lavender Rolls Royce. The wedding present included New York financier Jay Gould's former chauffeur.

The couple lived on their Wickliffe estate, although Cleveland's social crowd demonstrated little interest in the playboy son of a respected citizen coupled with a divorcée burdened with a working-class background.

Laura Mae Corrigan, the daughter of a Wisconsin handyman, became one of Europe's most influential social celebrities. *Courtesy of Cleveland State University, Cleveland Press Collection.*

Contributing to Cleveland's snub of the wealthy couple, Price McKinney regarded Laura Mae as a fortune hunter. McKinney removed the Corrigan name from the steel company, renaming it McKinney Steel. Selling Nagirroc and abandoning Cleveland, the Corrigans encountered a comparable indifference in New York, even after expending hundreds of thousands of dollars in parties, clothing and gifts in an attempt to purchase social approval. Following New York's rebuff, the couple rented homes in Rome, Venice, Palm Beach, London and Paris.

HOBNOBBING WITH ROYALTY

By the early 1920s, Laura Mae had discovered the ideal constituency to fulfill her ambitions. Cash-strapped British aristocrats and nobles, needing wealthy contacts to help maintain their affluent appearance, grudgingly accepted the hospitality of rich American citizens. To enhance her opportunity, the aspiring hostess hired a teacher to coach her in the conventions of British society. In London, Laura Mae met social

hostess Alice Keppel, a former mistress of King Edward VII. Alice and her husband, George Keppel, shared both aristocratic backgrounds and a lack of money. The two decided her involvement with wealthy lovers afforded a straightforward means to maintain their grand lifestyle.

Laura Mae rented Keppel's notable mansion on Grosvenor Street, located in the exclusive Mayfair district of London, to host her parties. Her first event for Mayfair society created a welcome, although totally unplanned, sensation. A rumor, aiming to mock the American hostess, claimed Prince George would attend the party. The prince, aware of the gossip and its malicious objective, actually did pay a visit to Laura Mae's gathering. Elated by his presence, she stood on her head, a practice destined to become a tradition at her parties. She became an ardent friend and supporter of George and his wife, wisely gaining more influence by contributing to their favorite charities.

Laura Mae's social events grew in stature among Europe's lords and ladies; her reputation even extended into Asia. An extremely wealthy prince of India rejected an invitation from a leading American family, choosing instead to attend a party given by Mrs. Corrigan. In 1923, Queen Mary invited the Corrigans to her royal enclosure to view the internationally prestigious Epsom Derby.

THE HOSTESS'S UNEXPECTED BUSINESS SAVVY

Although Jimmy and Price McKinney each owned 40 percent of the company's stock, McKinney, as president, exerted the control. While Laura Mae entertained European royalty, Jimmy spent more time in Cleveland, monitoring McKinney's business decisions. Laura Mae eventually rejoined her husband to devise a plan resulting in McKinney being ousted from the company. Through their inheritances, the grandchildren of Stevenson Burke, an original partner, owned a portion of the company's stock. Laura Mae persuaded them to part with enough shares to give Jimmy a 53 percent majority, selling virtually everything she owned to raise the needed $5 million

In 1925, the husband-and-wife team attended a board of directors' meeting, announcing to the shocked board that they now controlled the company. The two immediately relieved Price McKinney of his responsibilities as president. Within a few months of his expulsion, McKinney

As the widow of James Corrigan, Laura Mae inherited a substantial portion of her late husband's steel company. This picture depicts Laura Mae in Cleveland on a business trip in 1930. *Courtesy of Cleveland Public Library, Photographic Collection.*

committed suicide. The sixty-three-year-old walked out of a business meeting, drove home to his Wickliffe mansion and fired a bullet into his head. Less than ten years later, in 1935, Price McKinney Jr. died from a rifle shot to his head just a few feet from where his father had taken his life.

Three years after the business coup, forty-seven-year-old Jimmy died of a heart attack after walking from the Hollenden Hotel to the Cleveland Athletic Club on Euclid Avenue. In 1928, four females owned virtually all of the steel company's stock: widows Mrs. Jimmy Corrigan, Mrs. Price McKinney and Mrs. Stevenson Burke, along with Mrs. Parthenia Ross. The Cleveland Cliffs Company gained control of the business by purchasing stock owned by Mrs. Corrigan and Mrs. Ross. Five years later, Republic Steel acquired the Corrigan company. Laura Mae sold her remaining shares. Twenty armed guards lined "Short" Vincent between East Ninth and East Sixth Streets as three armored trucks transferred her fortune from the Union Trust Company to National City Bank. Following the sale, Laura Mae lived on proceeds from a tax-free annuity that paid her an annual income of $800,000.

Wallis Simpson's influence on King Edward VIII temporarily hindered Laura Mae Corrigan's social status in England. But Edward's abdication to marry Wallis (the two are shown above on their wedding day) allowed Laura Mae's quick return to favor. *Courtesy of Cleveland Public Library, Photographic Collection.*

Continued European Triumphs

Laura Mae returned to Europe, creating novel parties incorporating costumed waiters, orchestras, acrobats, jugglers and dancers from the Royal Ballet. A typical *Arabian Nights* party featured servants dressed as "Orientals." Guests at her breakfast table sometimes uncovered envelopes containing spending money for the day. A female guest could discover a quart of her favorite perfume, while a male visitor might savor five hundred expensive cigarettes, along with a gold lighter and jade cigarette case.

Laura Mae demonstrated excellent judgment in selecting her guests. She cultivated Princess Marina of Greece long before the princess entered British society by marrying Prince George, the Duke of Kent (the fourth son of King George V). Laura Mae sent Marina a mink as a wedding present. The duke and duchess rose to become London's most influential social arbiters, in the process enhancing the hostess's stature.

The Prince of Wales (the future Edward VIII) presented a serious impediment to Laura Mae's continued advance within British society. Edward mostly ignored Laura Mae, especially after Wallis Simpson selected the members of Edward's social set. When Edward became king in 1936, followers of British society predicted Laura Mae's downfall. But the savvy hostess prudently cultivated a friendship with the Duke and Duchess of York. When the duke became King George VI as a result of King Edward's abdication to marry Wallis Simpson, Laura Mae rose to the undisputed position as London's leading hostess. During Edward VIII's brief reign, Laura Mae vacationed in America. One of her parties, held at the Waldorf-Astoria, included perfumed pigs imported from Leonard Hanna's Cleveland farm.

In addition to her London triumphs, Laura Mae's star shone brightly in Paris. During this period, she entered an unexpected phase in her remarkable life.

The American Angel

Laura Mae, the last guest to leave the Ritz Hotel in Paris as World War II spread to France, initially joined French refugees fleeing to England. Unexpectedly changing her plans, she fled to Vichy, the de facto French headquarters during the war. Sharing a bathroom with six other women

Above: Laura Mae Corrigan continued her social work in Paris into 1942, the year a photographer took this picture of the war-torn city. *Courtesy of Cleveland Public Library, Photographic Collection.*

Left: Laura Mae Corrigan distributing food in full party dress. Each outfit cost thousands of dollars. Her hair is actually a wig, for Laura Mae was completely bald. *Courtesy of Wickliffe Historical Society.*

in a fourth-rate hotel, the millionairess coordinated efforts to feed, clothe and provide medical assistance for French soldiers, war prisoners and their families.

Fearing her money could end up under German control, the U.S. government froze Laura Mae's funds, restricting her to a $500-per-month allowance. To continue her charitable efforts, she sold her jewelry, tapestries and furniture, in the process carving an alliance with an unlikely associate: Herman Goering, a leading member of the Nazi Party. Laura Mae and the Nazi administrator formed a deal in which Goering and a syndicate purchased her famed emeralds at bargain prices; in exchange, the Germans permitted her to organize a refugee aid program named La Bienvenue. Traveling freely between unoccupied and occupied zones, the former hostess turned relief organizer established milk stations and provided sandwiches, made at the Ritz in Paris, to soldiers and citizens in bread lines. In 1940, a truck struck her, breaking both her arms and a leg and creating a permanent limp.

Laura Mae managed to continue her relief efforts into 1942, but she finally exhausted her funds. She fled France through Lisbon, returning to London in 1944 to set up the Wings Club, a social organization for Allied air officers. In Europe, her war efforts earned her the unofficial title the "American Angel." More formally, she received the Croix de Guerre, Legion of Honor and Croix de Combatant from the French government and the King's Medal from the British government.

Following the war, Laura Mae returned to her previous lifestyle, hosting parties in London and Paris. In 1948, cancer ended the life of Laura Mae Corrigan while she visited a sister in New York. Her ashes are interred in the Corrigan family plot in Cleveland's Lake View Cemetery. Her sister, Laura Mae's only close relative, inherited most of the hostess's personal fortune. Laura Mae earmarked a pearl necklace, once valued at $350,000, to St. Alexis Hospital, but her sister reportedly paid the hospital $50,000 for the rights to the necklace. Laura Mae also awarded cash gifts to the many impoverished European nobles who had been her friends.

Laura Mae Corrigan became a historical character and oftentimes appeared to be bigger than life itself. It is interesting to note that this famous character had many facets that went into making up the grandest hostess of her time. We thought our audience might enjoy some insight into what made Laura Mae Laura Mae.

Laura Mae Corrigan appeared to be a very petite woman of maybe five-foot-one to five-foot-three; she was very slim and physically fit. We know this

Laura Mae Corrigan in a gown.
Courtesy of Wickliffe Historical Society.

because even in her late thirties she found it fascinating to stand on her head during her parties. Wrapping a band around her skirt, she would proceed to show everyone at the party her great physical ability.

Mrs. Corrigan never drank or smoked, which allowed her to party until the wee hours of the morning and still look fresh as a daisy. Her parties generally lasted several days; thus, being very fit was a requirement for Laura's vocation. Laura Mae did have an ego of great proportions, resulting in her having a facelift sometime in the 1930s. She would have been in her fifties at the time.

Laura Mae Corrigan had many titles during her long career, including "Dollar Queen," "American Angel" and one that was unflattering but used by Laura Mae to her advantage: "Queen of the Malaprops." My favorite example of this was a conversation in which she was involved, presumably discussing architecture. The term "flying buttress" came up. Laura Mae, in future conversations, used the term "flying buttocks." She was oftentimes the butt of many jokes due to her lack of education, but in all cases she moved forward. At one point, she said she enjoyed a reputation of being dumb.

Our Laura invented this ploy, which then allowed her to be extremely shrewd, catching her foes off guard. Marilyn Monroe also used Laura Mae's "playing dumb" tactic to her great advantage.

Laura Mae Corrigan had a condition that most women, I believe, would absolutely dread. Her condition was a disease known as alopecia, the loss of all hair. It is unknown when Laura contracted this condition—as best we can tell, probably in her forties sometime. All pictures show her with a great head of hair. These were wigs that were kept in a special trunk known as the "wigwam." When she went through customs on her many trips, all were forbidden to look into this trunk. Laura Mae, being athletic and wearing a wig, did run into some peculiar moments. One in particular involved diving off a high dive at one of her parties. Her bathing cap showed just enough of her wig to let everyone know she had hair. As she hit the water, the force of it all caused both cap and wig to come off her head. It was said that she set a new record for a human being under water, for she would not come up until cap and wig were returned to their proper place. That evening, our Laura Mae was fashionably late to her party, suggesting she had to go to the beauty shop to have her hair dried and set.

Throughout her career, it appeared no moment or circumstance could ever seriously embarrass Laura Mae Corrigan. Some could conclude that with all Jimmy's money she was immune to it all. I believe that this was not really the case. Mrs. Corrigan was so focused on all she did that she did not really experience the things that would be extremely negative to most folks. No matter whether it was her entertaining or her wartime efforts, she remained one-dimensional in her approach. When she locked into something she wanted to do, all else did not matter. This is what made for an unbelievable and complex character who, at her death, had the best title this world had to offer: the American Angel.

THE MILLIONAIRES' LEGACY

Frank Rockefeller's estate is now the site of Wickliffe High School and its athletic field. Rockefeller's old carriage house functions as the Board of Education offices. James Corrigan's land has been redeveloped into Pine Ridge Country Club.

Ridgemere Farm, the Price McKinney estate, became the home of Marycrest School and, in 1953, Borromeo High School and Seminary. The

high school closed in 1976. In 1991, Borromeo Seminary merged with St. Mary's Seminary, previously located on Ansel Road, to become part of the Center for Pastoral Leadership, located on the Wickliffe site. Dyke College, the Lake Montessori School and Lake Performing Arts have rented portions of the estate.

John Corrigan relocated to Los Angeles, where he died in an automobile accident. Mrs. Margaret Corrigan Williams, a first cousin once removed of Jimmy Corrigan, inherited more than $1 million from the Corrigan estate when Laura Mae died. Twelve years later, Mrs. Williams, then forty-eight, perished with her husband when a fire destroyed their Hunting Valley estate as they slept.

While Laura Mae shunned members of Cleveland's society, she contributed $5,000 each year to the city's Community Fund (later United Way). To honor her husband, she donated $25,000 to the Cleveland Museum of Art. The museum used the funds to purchase Cezanne's *Pigeon Tower at Montbriand*. Laura Mae traveled extensively. Her trips included visits to India, Africa, China, Siam and Persia. She supplied the Cleveland Zoo with fourteen animals (an elephant, two lions, a leopard, zebras and gazelles), obtained from an African safari, along with $5,000 to provide food for the animals.

4

FRANCIS DRURY

OIL STOVES AND THESPIANS

Francis Edson Drury in 1917 was one of Cleveland's wealthiest men, and yet most Clevelanders know little about him and, in particular, how he earned his money. This being said, Francis has left us with many reminders of himself and his family—actually more than most other famous Clevelanders. His Euclid Avenue mansion at about East Eighty-sixth Street remains in perfect shape. It is exactly as it was in 1912, when finished, thanks to our Cleveland Clinic, its current owner. Some years ago the clinic, as owner of this property, decided to spend several million dollars to return this old home to perfection. Basically, the Drury home is one of the few remaining mansions located on the north side of Euclid Avenue. The four remaining ones are the Mather, Beckwith, Drury and White mansions. The White and Drury homes are currently owned by Cleveland Clinic. As a side bar, if I may, I know oftentimes the Cleveland Clinic gets accused of not seeing the relevance of historical buildings, as many of the buildings it purchases are torn down. I believe most Clevelanders are totally unaware that the clinic spent over $6 million to preserve these two, now priceless mansions representing two of the finest built on Millionaires' Row.

As a young employee working in Springfield, Ohio, Francis Edson Drury received a challenging request from one of the company's owners: Drury needed to supervise the manufacture of several large boiler vats and finish production within one week. After Drury declared the request could never be accomplished in the required time, the owner retorted, "Young man, what must be done, can be done." Drury successfully completed the assignment

and, nearly fifty years later, remarked, "It was then I learned this important fact: when you encounter difficulties and obstacles, and you have seemed to have given all that was in you to overcome them, and are dead beat, there is still something more you can do. I never forgot the lesson and it helped me over many critical situations."

At the age of twelve, the Michigan native received his initiation into manufacturing by working as a night watchman in an iron foundry. As a teenager, he toiled in a boiler shop, later obtaining a position in a railroad's purchasing department. Drury moved to Cleveland when the railroad, through a series of mergers, relocated its purchasing function to the city. He worked for the huge George Worthington Hardware Company distributers in 1870 and 1871 and then for a small retail hardware store in which he held a financial investment. Following the store's bankruptcy, Drury obtained employment with the Springfield manufacturer.

Drury improved the design of a lawnmower produced by the Springfield company, reducing its weight by 50 percent while trimming production costs. He patented his invention, but his employer refused to provide any additional compensation for his efforts. Disgruntled, Drury moved back to Cleveland, forming a partnership with the Taylor & Boggis Foundry to manufacture his new invention. He quickly ascended to vice-president and general manager positions with the foundry. A competitor's unfounded patent infringement claim intimidated the conservative Taylor & Boggis Company into discontinuing production of the lawnmower. Remaining with the company, Drury involved himself in the manufacture of other products, including a newly developed oil stove. But the owners, nearing retirement, resisted Drury's ambitious plea for expansion, forcing him to leave the company.

Francis Drury had many jobs growing up in Cleveland, always gaining valuable experience that paid big dividends later in life. Francis was a thinker, a man of very even temperament, a man blessed with great common sense. He appeared to be a people person, a man's man, conservative and humble. Through a series of jobs, Drury became fascinated with the making of kerosene stoves. Always wanting to be in business for himself, but not having the necessary capital, he sought out an investor. Fate treated him kindly, as one H.P. Crowell, founder of the Quaker Oats company, was looking for an investment at this time. The two men got together a business plan and created a factory. This entity eventually became the largest kerosene stove manufacturer in the world, and when Francis Drury retired from the board in 1930, their company was known as the Perfection Stove Company. Francis had a grand opportunity dropped in his lap in 1905. John D.'s

Standard Oil Company wanted to sell kerosene stoves to its customers for it had a great excess of kerosene. Standard Oil was now converting production from kerosene to gasoline, and thus demands for kerosene were down. Its warehouses were overflowing with the liquid. The plan was to convert its customers to kerosene stoves and use up the excess supply. Francis Drury had the best kerosene stove in the country, and his company and Standard Oil were both here in Cleveland.

In 1888, Drury co-founded the Buckeye Foundry Company, located on a railroad line near Woodland Cemetery. The company's principal products consisted of cast-iron frames used in school desks, hot-air registers and irons to press clothing. Drury's partner, Henry Parsons Crowell, also owned the American Cereal Company, the forerunner of Quaker Oats. Crowell served as chairman of Quaker Oats's board of directors between 1922 and 1944. As Crowell advanced in the cereal business, Drury dominated the foundry operation.

Just before the turn of the twentieth century, Drury diversified his product offerings. Recalling his production experiences at Taylor & Boggis, he developed an "oil-burning" cooking stove, a more convenient alternative to wood or coal stoves; more precisely, these "lamp stoves" used oil-based kerosene as the heating source. Renamed the Cleveland Foundry Company, Drury's business also manufactured a portable kerosene heater for home and business use.

In 1901, Drury partnered with John D. Rockefeller to promote the stoves and heaters. This practical business arrangement allowed Standard Oil to increase kerosene sales, a commodity the company already delivered to homes and businesses as a lighting source. Standard Oil continually sought new applications for kerosene, a byproduct of the oil refining process, since the company unprofitably dumped its excess supply into the Cuyahoga River. With Rockefeller's support, Drury developed a complete line of stoves and heaters, which Standard Oil salesmen sold to dealers using the trade name Perfection.

At the turn of the twentieth century, Standard Oil transported kerosene using horse-drawn vehicles. Attaching the Perfection products to the sides of a cart, deliverymen sold the stoves and heaters directly from their vehicles. Between 1905 and 1915, Drury and Rockefeller marketed ten million stoves. Drury later claimed money came in faster than the water gushing from his mansion's water tower.

Francis Drury continued to do great business with the Standard Oil Company until 1915, when The Standard decided to get out of the stove

industry. I trust the following from the Drury autobiography will fascinate, as Francis expressed his opinion of how Rockefeller's company treated him:

The Standard Oil Company of Indiana was the first section that indicated to us that they no longer wished to continue the distribution of oil stoves. The reason was that their mission had been fulfilled, and that they now had a market for kerosene products and there was no reason for their continuing in the oil stove business. At that time we had no sales organization, but they proved to be our best friends and gave us time to build up a salesman organization. And in the course of a few years one after another of the Standard Oil Companies turned over to us the distribution of our product, until at this time there remains only the Standard Oil Company of New York, which has the territory of New York and New England and has the distribution of our goods in that section. Through all our experiences with the Standard Oil Company acting as our distributors, our relations have been most cordial and profitable.

Drury changed his company's name to Cleveland Metal Products in 1910 and to the Perfection Stove Company in 1921. In 1916, following the government's breakup of Standard Oil, the newly created oil companies ended their relationships with Drury, concentrating instead on the burgeoning automotive gasoline business. Although the agreement with Standard Oil existed for less than three decades, Drury's company expanded into the world's largest manufacturer of kerosene stoves.

Because of his impressive business achievements, Drury gained entry into the elite group of wealthy industrialists residing on Millionaires' Row. Constructed between 1910 and 1912, Drury's twenty-five-thousand-square-foot English Renaissance Tudor home, containing more than forty rooms, still stands on the northwest corner of Euclid Avenue and East Eighty-seventh Street. Inside, the home featured a wide center staircase with ornate oak newels rising from the railings. A stone archway containing Italian tile connected a great hall to the living and dining rooms. The interior displayed carved woodwork, ornate ceilings, elegant furnishings and wood-burning fireplaces. A huge vault, hidden behind a wood panel, contained the family's silverware. On the outside, the home's red façade blended with an orange slate roof. Recessed arches, a bay window, a dark chimney and a brick tower enhanced the striking architecture.

Francis Edson Drury was a very wealthy man by the early 1900s, and like many of the wealthy Clevelanders of this period; it was time for

Francis to make the move to Euclid Avenue, Millionaires' Row. Thus, about 1908, he found a nice large piece of property on Euclid Avenue and East Eighty-seventh Street. In addition, he accumulated six more acres across the street. The property across the street contained a large mansion and a beautiful stable. Drury hired architects Meade and Hamilton, a famous pair in Cleveland, to design a fifteen-thousand-square-foot mansion. Work was begun in 1910 and finished some eighteen months later at a cost of $500,000. Since both Francis and his wife, Julia, enjoyed music, an expensive organ was built into the home. (Note: many avenue homes contained very expensive pipe organs.) Upon completion of his magnificent home, Francis was now ready to begin a new, massive project across the street.

The following is an article that appeared in *Architectural Record*, an extremely well-read magazine of the day. This article, written in 1915, gives great insight into the magnificence of the Drury home and its place on our famous Euclid Avenue:

A gratifying phase of the history of American architecture is to be found in the rapid development made in its residential work. This is most readily appreciated by following its progress as recorded on the illustrated pages of the architectural magazines. A casual survey of the early volumes of the Architectural Record *reveals a surprising lack of illustrations and text relating to the American residence, but a glance at the examples given makes this scarcity readily understood.*

Judging from the photographs from personal memories of the houses of two or three decades ago, one comes to the conclusion that the clumsier and uglier was their detail, the more uncomfortable their furniture and the more forbidding their decorations, just that much more unassailable was the social position of their owners. Their plans were unstudied, showing but little regard for convenience, for impressiveness of vista, or unity of effect; their style was derived from nothing and suggestive of the same, and each room was treated as a unit, regardless of its effect upon the house as a whole. It is hardly necessary to call attention to the improvement found in the best work of today. It is too evident and too well known to those who are interested and every architectural publication bears witness to it. A study of the plans, the details, the furnishings and the physical convenience shows a knowledge, skill and taste, which were undreamed of twenty years ago.

An excellent example of the better class of work which is being done today is found in the residence of Mr. F.E. Drury, of Cleveland, Ohio, the

architects of which are Mr. Frank B. Meade and Mr. James M. Hamilton, who have been responsible for many of the best residences in and around Cleveland. Designed for the accommodation of a small family, which would occupy it only during the winter season, it was to be sufficiently commodious to meet the requirements of any and all social functions and yet to be pre-eminently homelike and livable; not of the type which suggests a fancy stage setting in which the actors mope drearily between the acts. To be located upon Euclid Avenue, which, like many other avenue of homes, has been obliged to give way to the demands of business, one of the first problems to be solved was that securing the maximum of privacy. The site being a large corner lot, it was decided to place the house well back, thereby not only increasing the sense of privacy to the inmates, but also giving the house itself the setting of lawn, trees and shrubbery which is so desirable to one of its character.

The front of both house and lot has been developed in a rather formal manner, no approach being afforded from gate to doorway, both of which are permanently closed. The lot is surrounded by a brick wall surmounted by a stone balustrade. One reaches the house through a spacious, well planted court at the rear, which is entered directly from the side street, and also by means of a driveway from the front, which, following the west lot line, sweeps through an archway under the service wing into the court. This arrangement of driveways provides an efficient circulation for vehicles, especially desirable on the occasion of large social functions.

The comparative severity of the façade gives way in the courtyard to a more intimate and free treatment in half-timber. A restrained use of carving has been made in the timer work and here, as elsewhere throughout the house, the carving has been executed in the crude, vigorous manner characteristic of the Tudor period.

The service wing includes the garage and extending as it does to the rear of the lot, effectually screens from view a number of uninteresting buildings that adjoin it. The winding drives, the bits of lawn, the masses of evergreen planting, the old oak tree so painstakingly preserved, the vista through the archway and above all the interesting detail of the house itself, all combine to make this court one of the most effective features of the place.

The main entrance to the house is through the porte-cochere and, although at the rear, is the logical entrance, as it opens into the stair hall, thus preserving the privacy of the main hall. The rooms on the first floor are all of exceptional size and open together so as to give extensive vistas, yet in spite of this and of the richness of its appointments, the house does

not give the impression of a show place. Instead, it seems pervaded by the indefinable atmosphere of comfort and hospitality, which makes even the casual caller feel at home.

The house as a whole is carried out in the Elizabethan style, but in the furnishings considerable latitude has been taken and to this freedom from stylistic restraints is probably due much of its sense of livableness. A study of the old country houses of England has exerted a strong influence in leading people away from the idea of furnishing and decorating in strict conformity to style. Those old houses, in which many generations of cultured occupants have left their impress, represent the best that the Anglo-Saxon has done in home making and a study of them makes obvious the fact that much of their charm is due to the little alterations and additions which have relieved their stiffness and severity without detracting from their dignity.

That the lesson derived from these interesting legacies from the past has been put to practical use is apparent in some of the most successful residential work of today, but it is a lesson which must be thoroughly studied, for when the application of it is undertaken by an unskilled hand, the result is most likely to be a hodge-podge.

The main hall of the Drury house stretches across the front between the living room and the dining room and is finished with a high oak wainscot and stucco frieze, true to the period; but in the furnishings, although in part conforming to the room, a distinct Chinese note has been introduced. The window cornices are finished in red and gold lacquer to match two old standards which flank the front door, while a settle and two small tables in natural teakwood are grouped about the fireplace. Draperies in harmony with the lacquer colorings and rugs woven to Chinese designs give the final touch.

In the living room an even greater range of styles is apparent and so rich are the materials used and so strong is the color scheme that, were it not for the predominance of English forms, the plain color in wall hanging and draperies, the masses of black in rug and furniture covering and the somber tones of oak and walnut, the room might easily have resulted in a riot.

The music room, which is the only room on the first floor having light enameled woodwork, has a high paneled wainscot, above which is painted a decorative landscape, the prevailing tones of which are soft, deep greys. A pipe organ occupies a space built out from the rear of the room and is concealed by a screen of simple design. The console from which it is played stands against the wall of the living room between the openings to music room and hall, thus removing the performer from too close proximity to the instrument.

The dining-room would be the natural place to carry out a scheme of pure period furnishings and here indeed the furniture is true to the traditions of the period of William and Mary, yet considerable modification of detail is apparent in the different pieces, thus avoiding the cut-and-dried effect of the regulation "set." The carved screen before the pantry door is, of course, an anachronism, yet one that is altogether pleasing, or will be when the temporary fabric is replaced by some interesting bit of old tapestry or embroidery.

The butler's pantry and kitchen have every facility for efficient culinary service. In addition to the large range in the kitchen, an electric cooking table in the butler's pantry is provided with every form of cooking appliance. China cupboards with glass doors line the walls and pastry tables, carving tables, sinks, drawers and cupboards provide an equipment capable of taking care of any demands that may be made upon it. A vault of generous proportions insures safety to the silverware and the flat silver trays of the sideboard are fitted to slides within it, thus facilitating their transfer from dining room to storage.

There is no library in the house, but, instead, a stack of bookshelves behind leaded glass doors fills one long wall of the second floor hall, close beside the door leading to the sitting room. As this room together with the two adjoining bedrooms constitute the owner's suite and is the natural place for reading and writing, the books are nearly as accessible for reference as if housed in a room set apart as a study or library.

The four main bedrooms are carried out in various English styles. In one the furniture is of rosewood and is executed in the spirit of Chippendale's French period. Another is furnished in oak of the Jacobean period. The daintiest of the rooms has furniture of light Italian walnut on which the veneers are laid in panels, which are outlines with narrow bands of rosewood. The effect of the rich wood is further enhanced by a restrained use of painted decoration in Celadon green.

The fourth bedroom is extremely simple, having mahogany four-posters with other pieces to match and depends largely for its decorative effect on the quaint little chintz patterns used for wall hangings and draperies.

To the critical eye, there may be apparent some things about this house that might have been better done or might better have been left undone—who ever saw anything that could not be criticized or improved?—but, taken as a whole, it has stood the test of occupancy.

Its plan is simple and convenient; its detail is consistent with the style to which it conforms; it is adapted to the requirements for which it was built; its general effect is pleasing to the eye, and above all it has a homelike effect.

These seem to be the great things demanded in a home, and if they are, this one certainly measures up to the standard.

Francis and Julia, it appears, loved elaborate landscape, landscape that was designed to their view to take one's breath away due to its extreme beauty. Although most mansions on Euclid Avenue had some of the most beautiful gardens in the entire world, Francis by design wanted to exceed them all, and he had the land to do it. About 1913, Francis Drury began to create a garden paradise, which became known throughout the county as Euclid Avenue's Oasis. I think to give our readers a full feeling of just how magnificent this garden was, I will quote from an article that appeared in a magazine of the day called *Country Life*:

Aladdin's lamp! Who at times has not sighed for that mysterious crystallizer of wishes and dreams into actualities? Who, having it, would not cry, "Give me my castles in Spain! Give me the gardens of my dreams." We may cry in vain for that gabled lamp and sigh to no use for a castle in Spain, but the gardens of our dreams need not end with the dreaming. That those desired and lovely creations of our imaginations can be made to grow into living things of exquisite beauty, even under most adverse conditions, is amply proved by the development of The Oasis—one man's dream garden which came true—a veritable bit of fairy forest which sprang up in the heart of a crowded city.

The story of its creation seems one of modern magic, for in the space of just one year, the Oasis rose to its full-grown beauty. Five barren city lots turned into a woodland, a house excavation became an alluring grotto, a hydrant a trickling brook and a hollow a sky-reflecting pool.

This garden occupies four acres in the heart of the city of Cleveland. Originally, the property was the site of five city houses and beyond one or two trees was bare of vegetation. Even the soil, to a depth of five or six feet, was of such a sandy texture that all top soil had to be made.

Except for a slight rise to the right, as one entered, the land ran back in a level stretch for some distance and then rose irregularly to a height of from twelve to fifteen feet so that the garden design was worked out on two levels. The front portion contains an open stretch of lawn and a flower garden. The higher portion at the rear being developed in a more purely naturalistic way, with rocks, trees and water, as a screen for the vegetable gardens beyond.

As the residence of the owner was not on the property but stood directly across the street, the entire tract was utilized for the garden. A low wall

built of the same dull red brick used in the house occupied by the owner, with a screen planting of trees and shrubs behind it, runs along the street, effectively enclosing the garden on that side. The entrance is formed by two small gateways that lead into paths cunningly curved so as to afford the passerby only a limited glimpse of the loveliness beyond.

Once within the garden, every advantage was taken of existing conditions and of the topography. The main axis of the design lies from the entrance over a long, narrow lawn, forming a charming vista surrounded by trees and shrubs and finding its climax in the depths of a fern-clad grotto. This was designed not only to afford a pleasing restful stretch of turf but with the idea that it could be used as the amphitheater of an open-air theater, to which use it has since been put with great success. The grotto and its surrounding planting make a stage setting of rare beauty.

The second axis lies along the right side of the property through a small formal flower garden that is screened in on all sides so as to give it seclusion and a background for the riot of its multicolored bloom. At the far end of this garden, the axis terminates in a cascade, which daringly but happily ties the garden to the informal planting beyond.

As a source for this cascade the idea of creating a small lake in the hollow above the grotto developed. So everywhere in the garden the parts are inter-related and beauty and utility go hand in hand. Every possible natural advantage has been made the most of. The steps of the grotto, the lake, the cascade, etc., all seem to have grown naturally from the topography under the skill of the designer.

The planting everywhere was studied with great care and its masses were so arranged as to form heavy screens about the paths that curve so artfully that each turn unfolds a new and charming picture until, in spite of the limitations in its size, one gains a sense of space and infinite variety.

Above the cascade one comes upon a charming little figure modeled by Chester Beach, exquisite in line and place in a setting so completely harmonious that with no start of surprise or intrusion you feel you have come upon the soul, the very spirit, of the garden—its very spirit, poised lovely, shy, yet unafraid, amid her rocks and ferns and sheltering trees. Standing with upturned face, one hand raised to the heavens in a mute appeal for the life-giving water, she stretches forth her other hand to give it again to the garden. The thing is exquisitely done and seems to tie the garden to the heavens.

In fact, the whole thing is so well done that in its charm one forgets that it did not just happen so, that it was made—that every stone was placed

just so for just such an effect and that most of them were hauled from an abandoned quarry ten miles away, many of the weighing from one-half to eight or ten tons, and that weathered sand-stone was selected for use because it was light and porous and easy to handle and because moss and lichens grew easily on it. Every tree and shrub—yes, every fern—were each selected with painstaking care for the particular place they occupy. The trees, which seem so at home just where they stand are not natives but were transplanted full grown, with such an understanding of their needs that they have not faltered in their growth.

Modern magic it surely is where such a fairy oasis can be made—such a landscape picture painted—not with pigments but with the things that pigments usually paint.

Twenty servants supported the mansion's daily activities. In 1912, the Drurys' magnificent living room provided the setting for butler William Bygrave and housekeeper Katherine Gassman's marriage, while their working-class families and guests looked on in awe.

Besides his mansion, Francis Drury left other marks that represent his success. Namely, he left the Old Cleveland Playhouse, which he founded along with others, and his Cedar Hill Farm in Gates Mills, Ohio. Today, we know this property by a different name: Gilmour Academy, a well-known prep school. Drury also left a home on Drury Lane, currently located in our community of Waite Hill. All are so impressive that one is prone to ponder what this man did to acquire such wealth. May I tease our readers a touch by suggesting that there was a great connection between Francis Drury and our most famous Cleveland citizen, John D. Rockefeller?

The Drury family had a great history in the United States dating back to the Revolutionary War. Francis and his parents migrated to Cleveland from Michigan sometime before the Civil War as best we can tell. From a young age, Francis was a hard worker. His education was about eighth-grade level, common for those times. One of Francis's early jobs was with the railroad here in Cleveland. When he was a young lad, he had the horrible job of bolting boilerplates to the bottom of boilers that were used in the railroad locomotives of the times. According to Francis, he had to slide under the boiler in a very tight space, often scraping his skin as he attempted to perform his job. Many times, the older workers played jokes on Drury as they blocked his exit. After returning home from work one day, his mother saw how his body was full of bruises. She immediately made him quit that job, as any good mother might. The Drurys had a friend by the

Drury's residence in Gates Mills, currently the home of Gilmour Academy, bears an intended resemblance to the Euclid Avenue mansion. *Courtesy of Cleveland State University, Cleveland Press Collection.*

name of Remington (first name) who got Francis a new job in the hardware business. One should note that the kind deed of friend Remington was not soon forgotten; currently, Francis Drury's great-grandson bears the name of Francis Remington Drury.

Through a series of events, I became friends with this great-grandson. Rem, as I call Francis, blessed me with a marvelous gift, as he and his family were very pleased I was promoting the Francis Drury story. The gift was an autobiography written in Drury's own hand about 1928. I believe I am the only person outside the family to have such, and now our readers are about to get great insight into our character Francis E. Drury from his own writing. The following are relevant excerpts from this document of 1928, beginning with an introduction from Francis Drury's only son, Herbert Drury:

> *At my urgent request, my father, Francis Edson Drury, has written a short sketch of his life dealing principally with his business activities, which have*

been identified with Cleveland's manufacturing and banking, for the very considerable period of sixty years, a period of time greater than most men find it possible to be strenuously active.

My father came of the sturdiest of Colonial and pioneer stock and many of his ancestors served in the Colonial, Indian and Revolutionary Wars.

He speaks of his grandfather, Elihu Drury, who was a Michigan pioneer.

Elihu's father and grandfather, Caleb Drury, Junior and Senior, both served in the Revolutionary War, as did his mother's grandfather, Nathaniel Hudson.

My father's grandmother, Lovina Wade, married Elihu in North Rose, near Clyde, N.Y. She was descended from two Colonial governors of Massachusetts, Governor Thomas Dudley and Governor Simon Bradstreet.

Lovina Wade Drury's father and grandfather, Alverson Wade, and Rev. Dudley Wade, both served in the Revolution, and her grandfather on her mother's side, Joseph Munger also served.

Now we turn to the writing of Francis Drury as he learns a valuable business lesson:

I would like to interrupt the narrative here to describe an incident which I think had much to do with my future career. I was the general manager of the plant and Mr. Mast had a partner who was a wealthy sugar planter and had a sugar mill in New Orleans. One day this gentleman walked into the office, it was on Monday as I remember, and said he had a carload of goods going to New Orleans on the following Monday. He laid on my desk plans and specifications for several large boiler vats to be made of boilerplate, and said, "I want you to make these vats and have them ready to go into the care next Monday." I glanced at the plans and I said to him, "Impossible, there is no boiler plate here to make them of and if there was, the time is too short to do the work." His answer was, "The car goes next Monday," and started for the door. I called out to him, "Impossible, it can't be done in the time." He turned in the doorway and raising an admonishing finger said, "Young man, what must be done, can be done," and disappeared.

I was much disturbed because he was one of the important owners of the business and I naturally did not like to fail him. After biting my fingernails for a few minutes, I started, and telegraphed all nearby cities for the material. I finally found it, had it shipped by express, at some cost, believe me. Had a truck meet the train when it came in. Had men waiting at the forge with their leather aprons on and their sleeves rolled up to tackle

the job. They worked day and night, and all day Sunday, and on Monday we loaded the vats in the car. It was then I learned this important fact, that when you encounter difficulties and obstacles and you have seemed to have given all that was in you to overcome them, and are deadbeat, there is still something more you can do. I never forgot the lesson and it helped me over many critical situations. Years after, I told this story to a convention of our district managers and traveling salesmen from all over the country. It made a deep impression and I heard of it from distant quarters, and in some of the offices of my own staff there appeared a little framed piece of glass with these words printed on it: "What must be done can be done."

In 1915, businessman Charles Brooks and eight friends (including Raymond O'Neil, the music and drama critic of the *Cleveland Leader*) founded an avant-garde theater organization. A few months later, Drury discussed the group's aspirations with dinner guest Myrta Jones, a social reformer and one of the theater company's founders. Drury invited the troupe to use a vacant house sitting on land he had acquired on the south side of Euclid Avenue, opposite his mansion. In May 1916, the company presented its initial offering, *The Death of Tintgiles*, a marionette show, in the dining room of the house. The group erected a stage in the attic to perform its second production. Meanwhile, O'Neil married Ida Trest, an actress in the theater company; the two lived in a previously abandoned but now remodeled cow stable on the same site. The fledging theater company relocated its stage to the dining room of O'Neil's new residence. These humble beginnings launched one of Cleveland's superb cultural assets: the Cleveland Playhouse.

But Drury had purchased the land across from his home for a different reason. He developed a striking six-acre garden, extending from Euclid Avenue to Carnegie Avenue, known as the Oasis. This charming refuge contained waterfalls, fountains, reflecting pools, a lily pond, a pagoda, an amphitheater, greenhouses, woods and paths lined with flowers. According to folklore, the Drury family reached the garden area using a tunnel constructed under Euclid Avenue, but this fable is most likely false. When Drury initiated his garden project, he donated $6,000 to the Cleveland Playhouse, allowing the company to purchase an empty church on Cedar Avenue for its productions. Using bricks and lumber from the old home and barn on Euclid Avenue, the playhouse remodeled the church into a 160-seat theater.

After residing on Euclid Avenue for less than fifteen years, Drury followed many of his well-heeled neighbors by relocating to an affluent eastern suburb in 1925. Originally employing the prestigious Walker & Weeks firm

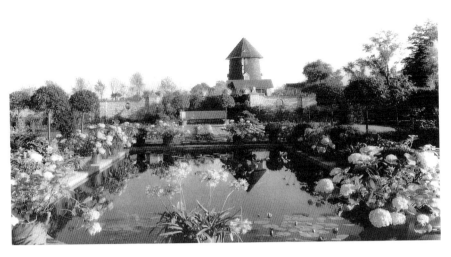

Cedar Hill Farm, Lily Pond. *Courtesy of Western Reserve Historical Society.*

to design a country home, Drury completed the project by creating a more elaborate estate with architect Charles Schneider, the designer of Stan Hywet Hall in Akron. Spending about $2 million, Drury developed the 133-acre Cedar Hill Farm, an opulent estate located on the corner of Cedar and S.O.M. Center Roads in Gates Mills. Christened the Tudor House, Drury's new mansion intentionally bore a striking similarity to his previous Euclid Avenue residence. The forty-one rooms accommodated fourteen fireplaces, each with marble obtained from a different country. A different type of wood highlighted every major room. The mansion's solid oak front door measured nearly four inches in thickness. Drury's oak and mahogany bed weighed one thousand pounds.

Drury moved the Oasis, incorporating the previous Euclid Avenue garden into an extensive sanctuary encompassing more than twenty acres. Two marble pillars flanked a pond in the backyard. A working farm, adding to the estate's allure, housed purebred Guernsey cattle to produce milk, cream and other dairy products. In total, Cedar Hill Farm contained seventeen buildings, including a creamery, vegetable-cleaning building, toolshed and five acres devoted to greenhouses for growing both vegetables and flowers.

Drury sold the Euclid Avenue mansion and donated the previous Oasis land, then vacant, to the Cleveland Playhouse. Returning to the site of its initial productions, the playhouse constructed two theaters; the organization remained on the former garden lot for eighty-four years. Until its move to

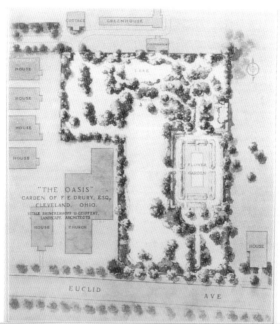

The Oasis, Drury's garden in the heart of Cleveland. *Courtesy of Western Reserve Historical Society.*

Playhouse Square in 2011, the Cleveland Playhouse honored its benefactor by naming one of its stages the Drury Theater.

Surprisingly, Drury and his wife resided on Cedar Hill Farm, considered among Ohio's grandest properties, for less than one year. After completion of the Gates Mills mansion, Drury's wife staged an open house, inviting Cleveland's foremost society members to admire their new residence. Mrs. Drury hired a famous New York caterer for the occasion and paid $3,000 for cut flowers. But only forty members of the city's elite, a mere 15 percent of those invited, attended the event.

Anticipating expansion of their eastern suburban development and rapid transit project, Cleveland's prominent Van Sweringen brothers had coveted Drury's Cedar Hill Farm land for several years. Drury convinced the owner to sell him the land after he guaranteed the placement of his new home would block any attempt by the Van Sweringen interests to redevelop the property. As an added inducement, Drury allowed the present owner to remain on the premises and continue his profitable farming activities. But in outmaneuvering the politically influential Van Sweringen brothers, Drury created adverse social consequences for himself. Compounding his social difficulties, Drury had married Julia Robinson within two years of the death of Frances Perkins, his first wife; many of Drury's acquaintances still retained fond memories of Frances. Julia's Catholic faith also worked against her acceptance into Cleveland's elite society circles.

The social snub, leaving Drury's wife in tears, prompted the couple to leave the Cleveland area. The two spent their winters at an estate in Augusta, Georgia, and their summers either on a private island in the Georgian Bay or in a New Hampshire retreat. The spring and fall seasons found Francis and Julia residing in an apartment on New York's Fifth Avenue. Ironically, their Gates Mills home would later become, and remains to this day, a Catholic college-preparatory school.

In addition to his contributions to the Cleveland Playhouse, Drury helped establish the Cleveland Music School Settlement and donated financially to the Cleveland Orchestra, Western Reserve University and the Case Institute of Technology. Before Drury died, he purchased annuities for his son, grandchildren and a group of twenty friends, relatives and servants; five colleges received the remainder of his estate. Francis and Julia Drury remained married for fifty years, the union ending with Francis's death in 1932.

One evening, Francis Drury and Julia, as it is told, held a dinner party at their new home. Among their guests were some younger folks (note that Drury at this time was already in his sixties) who talked about starting a

unique new theater. Drury, always supportive of the arts, listened and was impressed with what his young guests wanted to accomplish. I am sure after careful consideration—the Drury style—Francis had an idea for the new theater location. Drury, you see, owned a mansion across the street that was part of his garden property. This became the first location for what was to become the world-famous Cleveland Playhouse. Francis Drury was to eventually expand his gardens and remove the mansion, but for now the theater had a home.

It appears the new theater had a home for a couple of years in the mansion. Success began to grow. When it came time to expand the Drury Oasis and demolish the mansion, Drury offered the theater group the old stable coach house, which was part of his property fronting Carnegie Avenue. After a short period of time, Francis decided to remove this coach house and stable to create room for his massive greenhouse. To support his young friends, he donated $9,000, which allowed the playhouse to purchase and move to an old church on Cedar Avenue (note that the altar now became a stage). Julia and Francis enjoyed their Oasis for about ten years. The theater was oftentimes held in this garden during this time. The ladies would attend wearing large hats, and the men would be attired in white flannel suits.

Francis Drury, after only some ten years on Euclid Avenue, became restless during this period (1916), and he formally retired as president from his stove business. Drury needed a project, it appears. As many of his contemporaries were migrating east to Gates Mills, Ohio, Francis decided to follow. He was somewhat familiar with the area since for years he had a summer place on Drury Lane, Waite Hill, Ohio. I believe Francis, in his travels, spotted a nice farm on S.O.M. Center Road in Gates Mills (today's Gilmour Academy). The farm was not for sale, but Drury began to court the farmer, attempting to create a sale. The Drury approach was unique in that he offered the old farmer lifetime employment for himself and his son-in-law on a futuristic farm that he was going to build. The farmer could keep all revenue from the farm after the main house was supplied with all the farm products it needed. The approach worked, and Drury became the new owner of 133 acres of farmland. At this point, we must note that there were other buyers who wanted this property—namely, the Van Sweringen brothers. This piece was the endpoint of the new rapid transit system that they were going to bring to Gates Mills from Cleveland, Ohio. Drury knew of these other buyers and thus worked with Farmer Wilson for some time to establish a relationship of trust—again, the Drury way.

A Stroll Down Millionaires' Row

Now Francis seemed to be ready to build his new farm. He intended to spend between $2 and $3 million, a testament to the Drury wealth. One problem still remained—with Julia, his wife. Julia, it appears, was content with living on Euclid Avenue, as she had become involved with the new theater and other charities about town. I believe Julia was not a country type, and living close to the city was just fine with her.

Francis Drury, being a practical man, needed to convince Julia of the need to fulfill his new dream. Recognizing that Julia enjoyed the mansion on Euclid Avenue and all its amenities, he suggested that he would duplicate the Euclid home at the farm. Not only would the new home be identical, but it would also be bigger so that they would have more room to entertain. If this were not enough to win over dear Julia, Francis also agreed to use now famous architect Charles Schneider, designer of Stan Hywet Hall, a massive home located in Akron, Ohio. Well, as best we know, Julia still was not happy with moving to the country. Francis had one more bribe left: he would send Julia to Europe for up to one year with a grand budget so that she could buy rare and expensive artwork, which would be displayed in her new home. This she agreed to do.

With Julia off to Europe, Francis Drury was now free to build one of the grandest country estates in the United States. I believe at this point in our story that all husbands can relate to Francis Drury and his relationship with his wife. Although my dear Susan generally agrees to things I have done to our home, there have been occasions when I have sent my own wife out of town in order to complete various changes or expansions. I get a joy out of surprising her upon her return, making sure the project is complete and ready for final viewing. Obviously, I do not do all to Susan's exact liking, but at this point she at least appreciates the effort. Spending millions, I believe Drury's thinking may have been along these lines. Francis made sure all landscape was perfect upon Julia's return. He created a most magnificent view for Julia out of her second-floor bedroom window by lining up two rows of trees some two hundred feet apart. Spring had to be something very special, as some one hundred trees were in bloom. The amount of land to construct this magnificent experience for dear Julia was about twenty-five acres in all. The landscape was also terraced, which only added to the great beauty that Julia (hopefully) would enjoy. (Note: the Euclid Avenue gardens were moved in their entirety to his farm in Gates Mills, Ohio, at a cost of $30,000.)

The farm was completed sometime in the early 1920s. The Drurys eventually sold their Euclid Avenue home as they moved out of the country. With the Euclid Avenue gardens having been moved, Francis was ready to

donate his land for the building of a grand new Cleveland Playhouse. It appears both Julia and he were in agreement on this move.

Dear Julia, with all that Francis did in attempting to please her, never did warm up to estate living in Gates Mills, Ohio. An event that resulted in the Drurys leaving the farm for good was about to happen. Both Julia and Francis were anxious to introduce their Cedar Hill estate and beautiful new home to Cleveland society. A massive party was planned for about five hundred guests. Three thousand dollars were spent just on cut flowers for the grand party. Caterers from New York were brought in to make sure every detail was perfect. Historically, dress for such an event would have been white tie.

The big day arrived sometime after 1925, with all details carefully planned. One could imagine that the house staff, about eight people, was busy for weeks in preparation for this coming-out party. (Note: about forty people were used to maintain the farm.) When one plans an event even today, once details are in order there is a feeling of great anticipation and joy as the big date approaches. So it was with the Drurys. Sadly, as best we can tell, only fifty or so of the five hundred invited guests showed up for the Drury party. The shock to Julia was unbearable as Cleveland society snubbed the Drury event. Folklore suggests some reasons for this end result. The Van Sweringen brothers were still very bitter about the Drurys taking the land and thus campaigned against the party with great success. Julia—months later, still in shock—talked Francis into leaving the farm for their home in Augusta, Georgia, never to return. A small staff was left behind to do minimum maintenance on the home and grounds. Drury ordered his farm manager, Mr. Brown, to dig up all the gardens and sell the plants, which broke Brown's heart.

Francis Drury eventually died in Augusta, Georgia, in 1932 at age eighty-two. Julia returned to the farm, oddly enough, sometime after Francis's death to stay a short time. She then moved to Moreland Courts, Shaker Square, Shaker Heights, Ohio—a Van Sweringen creation. Julia remained active in the Cleveland Playhouse, going to the theater and serving on the foundation board. She died at age eighty-three in 1943, having outlived both of the Van Sweringens, who died in the mid-1930s. Did she smile on their deaths? We do not know. The famous artwork, which Julia purchased, remained in the family for many years, owned by the Drury grandchildren.

I must reiterate at this point to our readers that some of the information you have just read is a result of my great friendship with Francis Remington Drury, the great-grandson of Francis E. Drury. Rem and I talk on a monthly basis, as he is now eighty-five years of age and living in Texas. All

conversations are a joy to both of us as we talk about the Drury legacy. One of my greatest gifts was the copy of the Drury autobiography Rem gifted me. Yes, it is great to be Cleveland's storyteller.

EPILOGUE

Drury's former Euclid Avenue mansion continued as a residence through 1935 and then served as a private club, boardinghouse, home for unwed mothers and halfway house for paroled convicts. In 1988, the Cleveland Clinic Foundation purchased and restored the edifice. The renamed Foundation House, opened in 1995, hosts receptions, graduations for medical students and Cleveland Clinic board meetings. The majority of the first floor bears a strong resemblance to its original appearance.

After standing vacant for more than two decades, Gilmour Academy purchased Drury's Gates Mills mansion. The Catholic college-preparatory school debuted on September 10, 1946, after construction crews converted barns into classrooms and remodeled the decaying Tudor House, steeped with rotting wood and broken glass. The Tudor House initially served as a freshmen dormitory, dining hall and classroom facility. The mansion is now used for wedding receptions, offices and lodging for the Brothers of the Holy Cross, founders of the academy. The school transformed a garage and servants' quarters into a senior residence, while juniors and sophomores inhabited an old icehouse. The cow barn became a gymnasium; architects transformed a four-car garage into a chapel and a toolshed into offices. Drury's master bedroom served as a study hall.

Drury Lane, constructed as an access road to Francis Drury's summer home in Waite Hill, survives to the present day.

The Perfection Stove Company eventually manufactured gas and electric water heaters, space heaters, furnaces, air conditioners, refrigerators and kitchen ranges. During the Second World War, Perfection developed military heating equipment used in the Arctic and also manufactured aircraft parts. Eventually merged into White Consolidated Industries, the Perfection line ended production in the early 1980s, a casualty of Japanese competition.

Following the relocation of the Cleveland Playhouse to Playhouse Square, the Cleveland Clinic purchased the former playhouse facility on Euclid Avenue at East Eighty-fifth Street.

OFF-STAGE DRAMAS AT THE AMMON RESIDENCE

Designed by prominent architect Charles Schweinfurth in 1886, the Euclid Avenue home of the initial Cleveland Playhouse productions also fashioned its own real-life dramas.

On January 9, 1863, Colonel John Henry Ammon married Mary Josephine Saxton, a nineteen-year-old Cleveland resident. Ammon returned to the Civil War battlefront almost immediately after the wedding ceremony. When the conflict ended, Ammon, with no tie to Cleveland except his wife, established a successful career in book publishing through his employment in Chicago, New York and Boston. Mary Josephine, now referred to as Mrs. Josephine Ammon, chose to remain in Cleveland. The year after completion of their Euclid Avenue home, Josephine divorced John, claiming desertion and gross neglect.

Josephine continued to live in her Euclid Avenue residence after acquiring a generous divorce settlement and a sizeable estate from her father, who had earned a comfortable living as a surveyor, farmer and real estate investor. Along with managing a thirty-acre vineyard to supply grapes to hotels and other businesses, Josephine devoted considerable time and effort to establishing and supporting Cleveland charities.

The most celebrated chapter in Mrs. Ammon's unconventional life unfolded after she befriended Miss Josephine Blann, a forty-five-year-old spinster. Although Blann's father had acquired the wealth to justify a Euclid Avenue residence, the street's refined society never accepted the family, partly because of his rumored livelihood as a Civil War bounty jumper. These unscrupulous blackguards enlisted in the army, collected a sizable bounty, deserted the troops and then reenlisted, sometimes as many as thirty times, collecting a new bounty with each reenlistment.

Following her father's death, Josephine Blann and her widowed mother frequently visited, and sometimes lived in, Mrs. Ammon's home. Acquiring an estate exceeding $70,000, the mother and daughter often appeared to possess more money than intellect. A judge, with little scrutiny, declared the mother an imbecile and the daughter an idiot. A questionable guardian attempted to acquire control of Blann's estate, but the mother died before the court implemented the guardianship. On the deathbed of Josephine Blann's mother, Ammon promised to care for the daughter. When the guardian arrived to assume custody of Josephine and her coveted estate, Ammon claimed she had no idea of her whereabouts. Authorities searched both Mrs. Ammon's Euclid Avenue home and her summer residence in Collinwood but failed to uncover the missing Miss Blann.

In court, Ammon testified that although she did not know the whereabouts of Blann, she did have "an idea" regarding where Blann may have fled. After refusing to divulge the details of her theory, the judge sentenced Ammon to prison for contempt of court, where she would remain until she disclosed the particulars of her idea. For the remainder of her life, Ammon claimed uniqueness as the only woman ever incarcerated for possessing an idea.

The martyrdom of Josephine Ammon, a woman of means and social position, generated national publicity. Preparing for a long imprisonment, Ammon moved her bed, several chairs, a rug and numerous books and pictures from her Euclid Avenue mansion to her new residence in the Cuyahoga County Jail. Hundreds of friends and sympathizers flocked to her Public Square cell to demonstrate their support and possibly to scrutinize her luxurious cubicle. Well-wishers brought flowers and food, although Josephine praised the jail's excellent

bean soup, often inviting her society friends to enjoy the unconventional cuisine with her.

After forty-one days, the novelty of lavish imprisonment waned, and Ammon finally revealed Blann's hiding place: a farmhouse in Chagrin Falls. Josephine Blann testified that she hid to save her life, believing the guardian would poison her to obtain the estate. For the remainder of her life, Miss Blann staged an unsuccessful legal battle to regain control of the assets.

Always leaning toward the eccentric side, Ammon publicized her past plight by constructing a replica of her jail cell in her Euclid Avenue mansion. Although living in relative comfort during her incarceration, Ammon observed the quandaries of others not as fortunate. The experience inspired her to work toward prison reform. Ammon visited the Ohio State Penitentiary several times, suggesting changes to improve conditions of the prisoners and frequently giving lectures at the penitentiary.

In 1892, at the age of forty-eight, Josephine Ammon died in her home. At her previous invitation, more than one thousand people, including newspaper reporters, attended her funeral. Laid to rest in Lakeside Cemetery, she had previously selected the spot southwest of the Garfield Monument because she perceived it as wild, unconventional and romantic.

5

THE WHITE FAMILY

SEWING MACHINES, TRUCKS AND POLO MATCHES

WALTER WHITE AND THE GREAT ESTATES OF GATES MILLS AND HUNTING VALLEY, OHIO

I could say, I guess, that the chapter you are about to read is my favorite, but then again, all my stories are favorites. It boils down to degrees, I believe. Some four years ago, I put together my first story entitled "Walter White and His Great Gates Mills Estate, Named Appropriately the Circle W. Farm." As time passed, I expanded this particular story to talk about four of the greatest estates in the county, all located within ten miles of one another and all built around 1917. These estates were the Circle W, owned by Walter White, founding brother of White Motors, Gates Mills, Ohio; Halfred Farms, owned by Walter's older brother, Windsor White, another founding brother of White Motors, Hunting Valley, Ohio; Cedar Hill Farm, owned by Francis Drury, founder of Perfection Stove Company, Gates Mills, Ohio; and Daisy Hill Farm, owned by the Van Sweringen brothers, O.P and M.J., builders of Shaker Heights, Ohio. All four grand estates were patterned after the European model of grand country living.

THOMAS HOWARD WHITE:
CLEVELAND'S SEWING MACHINE KING

Working in his father's Massachusetts chair factory, Thomas Howard White learned the art of craftsmanship while gaining an appreciation of entrepreneurship. In 1857, at the age of twenty-one, White invented a hand-powered sewing machine tiny enough to fit in a person's hand. Beginning with $350 in working capital, White founded a company to sell the "New England Sewing Machine," a device patterned after his original contraption. Because of financial constraints, White needed to collect the $10 selling price for a completed machine before beginning the manufacture of another.

In 1866, White sold his New England business, moving to Cleveland with partners Rollin Charles White and D'Arcy Porter, along with some of his best mechanics. His new Cleveland company gained proximity to customers and suppliers. Despite the same last name and similar backgrounds, Thomas H. and Rollin C. shared no blood relationship.

Thomas White acquired land, situated on the banks of the Cuyahoga River in the Flats, previously housing Samuel Ives's brewery, which had burned to the ground the year before. Constructing a new factory on this site, White's company grew into the world's second-largest sewing machine manufacturer. Daily production, beginning with 1 machine in 1866, expanded to 35 in 1876, 240 in the 1880s and 400 in the early twentieth century.

The company's success permitted three of its executives to reside on Euclid Avenue's Millionaires' Row: Thomas Howard White (8220 Euclid Avenue), Rollin C. White (6619 Euclid Avenue) and Henry Windsor White (8937 Euclid Avenue). Although these homes never rivaled the extreme opulence of some Euclid Avenue mansions, they still provided a luxurious setting for the owners and their families.

In the 1890s, the company diversified by producing roller skates, bicycles, phonographs and kerosene lamps. From 1894 to 1898, capitalizing on a national craze, White produced bicycles at the rate of ten thousand per year, along with 450,000 pedals for other bicycle manufacturers. Near the turn of the twentieth century, Thomas selected his son, Windsor, to head the bicycle division.

The company erected a seven-acre sewing machine plant at St. Clair Avenue and East Seventy-ninth Street in 1910, increasing its capacity from four hundred to one thousand machines per day. White's production, combined with the output from the competing Standard Sewing Machine Company on Cedar Avenue, propelled Cleveland into first place among the world's sewing machine manufacturers.

Left: Thomas H. White, founder of the White Sewing Machine Company, became one of Cleveland's most prosperous businesspersons. *Courtesy of Cleveland State University, Cleveland Press Collection.*

Below: Beginning in this factory on the banks of the Cuyahoga River, White's company expanded to become the industry's second-largest sewing machine manufacturer. *Courtesy of Cleveland State University, Cleveland Press Collection.*

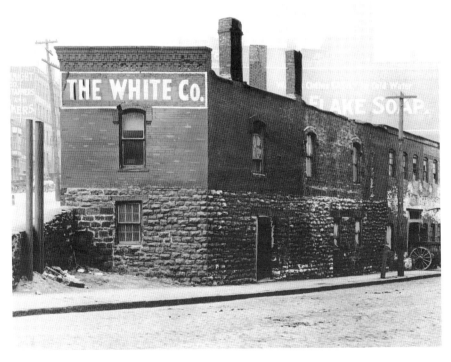

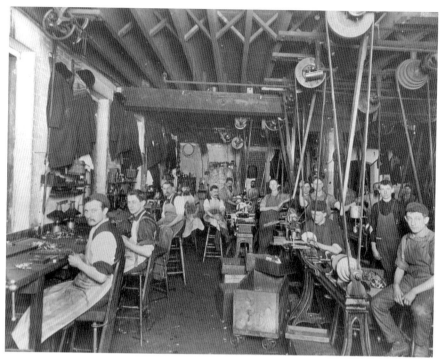

Above: The White factory produced about one hundred sewing machines per day in 1880. *Courtesy of Cleveland State University, Cleveland Press Collection.*

Left: Henry Windsor White's residence at 8937 Euclid Avenue is still in existence. *Courtesy of Cleveland State University, Cleveland Press Collection.*

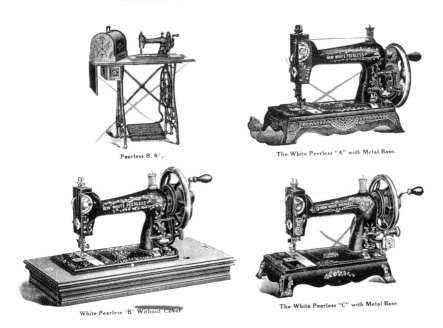

Peerless B. 6¼.

The White Peerless "A" with Metal Base.

White Peerless "B" Without Cover.

The White Peerless "C" with Metal Base.

White sewing machines, shown in this early catalogue, required hand cranking. *Courtesy of Cleveland State University, Cleveland Press Collection.*

White developed a company culture emphasizing respect for the workforce. He provided employees with kitchens, dining rooms and a clinic and often joined them during lunch. The company sponsored baseball teams, concerts by orchestras and bands and picnics at Euclid Beach. White's admirable reputation inspired three and four generations within a family to seek employment with the company.

On June 22, 1914, Thomas White died in his Euclid Avenue home, succumbing to what doctors described as complications from maladies. Henry Windsor White, Thomas's half brother and an early company investor and executive, died of pneumonia the following year. The sale of large blocks of inherited stock, a consequence of the two deaths, extended company ownership beyond the close-knit original investors.

From 1914 into 1920, two company attorneys served as chairmen of the board of the sewing machine and sister automotive company. In 1920, Windsor White assumed the chairmanship of both companies, remaining in that capacity until his retirement in 1927. In 1924, the company obtained additional capacity by relocating back to the Flats, acquiring the former Kundtz woodworking plant. The White company remained at the location into the early 1950s.

THE CLEVELAND AUTOMATIC MACHINERY COMPANY: SCREWS, BALL BEARINGS AND ELECTRIC CARS

The sewing machine industry, among the first to utilize precision manufacturing with standardized components, relied on a steady supply of parts adhering to precise specifications. In 1893, Thomas White founded the Cleveland Machine Screw Company to ensure both the availability and quality of components used to manufacture his sewing machines. The company also sold its products to manufacturers in other industries. From a three-story brick factory located between Cedar and Central Avenues, the company manufactured screws, lathes, drills, automotive gears and a selection of machine tools.

The product line expanded to include ball bearings for trucks, automobiles, bicycles, roller skates, typewriters, elevators, carpet sweepers and other applications. In 1889, inventor Elmer Ambrose Sperry partnered with the company to build a prototype of an electric automobile he had designed. John D. Rockefeller experienced his first automobile ride in the model later manufactured by the American Bicycle Company. Reflecting its expanded product line, White renamed the company the Cleveland Automatic Machinery Company in 1902.

Rollin C. White headed the subsidiary until 1900 but resigned this position, as well as his vice-presidential responsibilities with the parent White company, to become a founding partner in the Baker Motor Vehicle Company and the American Ball Bearing Company. Thomas White sold the company to French owners but remained as president until his death in 1914.

THE THEODOR KUNDTZ COMPANY: SEWING MACHINE CABINETS, BICYCLE WHEELS AND AUTOMOBILE BODIES

Thomas White presented a sewing machine to the wife of Theodor Kundtz in appreciation for her handling the White family laundry. Theodor, a woodworker by trade, constructed a cabinet to house the machine. White's gift and Theodor's cabinet inspired a partnership in which Kundtz constructed sewing machine cabinets and automobile bodies for the growing White businesses.

In 1872, twenty years after his birth in Hungary, the penniless Theodor Kundtz immigrated to America. Working for the Cleveland-based Whitworth Company, he built sewing machine cabinets. Five years later, Kundtz founded his own company in the Flats to supply all of the White Company's cabinetry.

Kundtz expanded beyond his reliance on White, establishing a bicycle-wheel factory in the 1880s and later building bodies for many of Cleveland's automobile manufacturers, including White, Winton, Peerless, Stearns and Murray. Kundtz further developed the company by constructing church and school furniture. In the early 1900s, his business employed 2,500 workers; by 1915, five factories consumed several city blocks. The once impoverished immigrant, now a millionaire, retired at the age of seventy-two to his estate in Lakewood. Constructed between 1898 and 1902, the home featured hand-painted ceilings, stained-glass windows and hand-carved furniture; the mansion even included a bowling alley.

In Cleveland, Kundtz's superb woodwork adorns the Cuyahoga County Courthouse and Trinity Cathedral. Nationally, more than five thousand churches in forty-eight states still display Kundtz cabinetry, while numerous schools throughout the country are equipped with his desks and chairs. The White Sewing Machine Company purchased the business when Kundtz retired. One of the firm's largest jobs involved constructing 62,781 chairs for the Cleveland Municipal Stadium.

ROLLIN H. WHITE:
FROM WHITE STEAMERS TO GASOLINE ENGINES

Just prior to the turn of the twentieth century, Thomas White purchased, for his family's use, an early steam-driven automobile manufactured by the Locomobile Company. The unreliable vehicle inspired Rollin H. White, one of Henry's sons, to substantially enhance the machine's performance. Combining inquisitiveness, mechanical aptitude and an education highlighted by a dual degree in mechanical and electrical engineering from Cornell University, Rollin effortlessly gravitated to automobile manufacturing.

Rollin offered his ideas, without success, to Locomobile. Thomas exhibited little interest in his son's growing passion, partly because he regarded the horseless carriage as a mere passing fancy. But Thomas

Rollin H. White motivated the White Sewing Machine Company to produce automobiles. *Courtesy of Cleveland State University, Cleveland Press Collection.*

allowed Rollin to use a corner of the sewing machine factory to experiment with steam-driven automobiles.

In 1900, under Rollin's guidance, the company manufactured fifty automobiles. Thomas did not attempt to sell these vehicles for six months, fearing a new, untested and expensive product might diminish his outstanding reputation as a sewing machine manufacturer. With a selling price exceeding $3,000, approximately quadrupling the Stanley Steamer's $850 cost, White's automobiles needed to be outstanding. After thorough quality, performance and capability assessments, the cars finally reached enthusiastic buyers. Thomas integrated horseless carriages into the White Company's product lines, conferring responsibility for the new division on three of his sons: Rollin H., Windsor T. and Walter C. White.

Initially, Windsor T. White, a graduate of Worcester Polytechnic Institute, controlled sales and finance, while Rollin's responsibilities included design and manufacturing. Walter C. White, with credentials including an engineering degree from Cornell University and a law degree from New York Law School, assisted his two brothers. Windsor, because of his aptitude for organization,

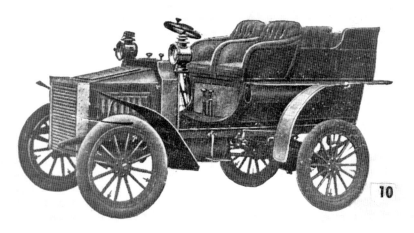

White Steamers, including this 1903 model, met with enthusiastic customer acceptance. *Courtesy of Cleveland State University, Cleveland Press Collection.*

soon emerged as president of the division. Walter ascended to vice-president responsible for sales and distribution. Also a vice-president, Rollin continued to improve the technical design and manufacture of the vehicles.

In the twentieth century's first decade, sales of White Steamers grew rapidly, assisted by superb publicity from Presidents Theodore Roosevelt and William Howard Taft. In 1905, Roosevelt rode in a White Steamer during his inaugural parade. Two years later, the Secret Service used two White vehicles to transport visitors from a railroad station to Roosevelt's home in Oyster Bay, New York. In 1909, President-elect William Howard Taft selected a White Steamer touring car as the first official automobile of the president of the United States.

At the turn of the twentieth century, no clear champion had yet arisen among steam-, electric- and gasoline-powered automobiles. By the end of the century's first decade, the more economical gasoline engine established its dominance of the automobile market. In 1906, Thomas White founded a separate company (the White Company) to manufacture automobiles. The new business, with the three brothers continuing in their previous capacities, developed an internal-combustion, gasoline-powered engine in 1909 and produced its first gasoline-powered truck the following year. Rollin's educational background assisted the company's transition from steam to gasoline; his senior thesis at Cornell University explored the development of the internal combustion engine.

In 1910, the company launched a new production facility at the corner of St. Clair Avenue and East Seventieth Street, next to the White sewing machine factory, with capacity to produce eighty-four vehicles per week (initially, forty steam cars, forty gasoline cars and four trucks). Working sixty hours per week, each of the more than one thousand employees earned about fourteen dollars in weekly wages.

Within the new facility, workers manufactured every part required in a vehicle's construction. Four months elapsed between receipt of raw materials and an automobile's completion. The company consumed forty-two days in painting, varnishing and upholstering each vehicle. On a given day, eight hundred automobiles could be in various states of completion throughout the factory. Within a few years, White ended production of steam automobiles as less expensive gasoline-powered vehicles conquered the market. But in the early period of automobile production, White sold more steam cars than any other manufacturer, even out-selling the illustrious Stanley Steamer. By 1915, continuing its quest for perfection, White offered a 100,000-mile warranty on its gasoline-powered automobiles.

Following his father's death in 1914, Rollin resigned from the White Company. In 1916, he and his brother Clarence co-founded the Cleveland Motor Plow Company to manufacture farm tractors, a niche market the White Company showed little interest in developing.

WINDSOR T. WHITE AND WALTER C. WHITE: FORSAKING AUTOMOBILES FOR TRUCKS

Windsor and Walter expanded their father's emphasis on employee goodwill by promoting employee orchestras, creating a library and employee store and developing a night school offering a variety of classes, including instruction on becoming a U.S. citizen.

White trucks and ambulances performed admirably during early twentieth-century military undertakings in Haiti, Santo Domingo and Vera Cruz. As a result, the company, renamed White Motor in 1915, received numerous lucrative military contracts throughout World War I.

A victim of Henry Ford's mass-production techniques, White ended the manufacture of its luxury automobiles after the war, concentrating instead on trucks and buses. In 1921, Windsor ascended to the company's

In 1917, the wheel and axel department of White Motors produced parts for White's army trucks. *Courtesy of Cleveland State University, Cleveland Press Collection.*

chairmanship, while Walter rose to the position of president. Windsor remained chairman of both the automobile and sewing machine companies until his 1927 retirement. Still expanding its physical environment, White Motor, in 1924, acquired the St. Clair property of the sewing machine operation that had moved back to the Flats.

In 1929, fifty-three-year-old Walter White died following a traffic accident at the intersection of Green Road and Fairmount Boulevard. With the retirement of Windsor and the death of Walter, the White family's interest in White Motor ended.

Brothers Walter and Windsor, founding members of the famous Gates Mills Hunt Club, became extremely fond of the Gates Mills, Hunting Valley area of Cleveland, Ohio. As this interest grew, they both began, in about 1915, to accumulate land to build their farms. Walter put together some 1,400 acres and Windsor nearly 1,200 acres. Of the two brothers, Windsor loved the spirit of life enjoyed by the great estates of Europe and thus tried to emulate them in his own version. Both estates were built with some of the finest working animals in the world. Each estate had a grand home and

Above: The White Motor Company received numerous military contracts throughout World War I, including construction of the trucks shown here in combat conditions in France. *Courtesy of Cleveland State University, Cleveland Press Collection.*

Left: Windsor White helped develop White Motor's strategy of switching from automobile to truck production. *Courtesy of Cleveland Public Library, Photographic Collection.*

barns with every type of farm animal, with particular care to the horse barns, as horses remained a passion of both men for the rest of their lives. Windsor's barn held forty horses, many of them polo ponies. Walter's one hundred horses were also mostly polo ponies. Both estates had state-of-the-art polo fields, each field being completely watered on a daily basis. Windsor had a swimming pool and a tennis court. Walter had a golf course and tennis court. Walter's children enjoyed a real log cabin for play, complete with electricity and running water.

Walter also built the largest cow barn in the state of Ohio, measuring six hundred feet across and with a height of three stories. Two hundred cows called this barn home; Walter had some of the first milking machines and his own bottling plant in the barn to complete the process. Each estate employed between thirty and forty full-time employees, a number that went up to seventy or eighty in the summer months. Costs to build each estate were over $1 million. Walter outspent Windsor, reaching almost $3 million by the time his farm was completed in 1923.

Walter's Circle W Farm had an interesting beginning. Walter was a bachelor, having been married for a short time and divorced. He said he was done with marriage. Thus, the beautiful million-dollar home, a Mount Vernon replica, was to be built as apartments for Walter and two buddies from the Hunt Club, Clark and Baily. As building progressed, Walter vacationed in the spring of 1916 in South Carolina for the spring polo season. We may note that Walter took his Cleveland horses with him by rail for the polo season. All was going well in Walter's life, but life was about to take a turn.

One nice sunny morning, some of the wives of the Cleveland polo players decided to go for a drive in the country to visit some of the old plantations, which still existed in this area of South Carolina. During this excursion, the women came upon a driveway leading to a great old southern mansion. They decided to drive up and knock at the door. A wonderful young lady answered. Her name was Virginia Saunders. Her family had owned the plantation since Revolutionary War days. Virginia thoroughly impressed the ladies that day, and they couldn't wait to tell Walter White about their experience. My observation at this point is that some things in history never change. Women just love to match up unsuspecting single men with their choices for a future wives.

Walter and Virginia did meet sometime over this spring trip, and Walter explained that marriage was not in his plans because his previous marriage had not been a pleasant experience. Virginia listened with great understanding. Upon hearing out Walter, she suggested that she write him

every day for one full year. At the end of that period, Walter would know her well and then could decide if the relationship should go further. Needless to say, the letter writing did the trick. Walter and Virginia were married in 1917 (my single female readers may want to take note here).

Walter, now a married man, had to inform his buddies that plans had changed concerning the new home at the Circle W. All took it well, and immediately work on the home changed into creating a marvelous family residence. Walter and Virginia had seven children over the next ten years. Family life on the estate was indeed active and productive.

ROLLIN H. WHITE: PIONEERING IN FARM VEHICLES

Thomas White and many of his immediate family remained in Cleveland their entire lives, expanding their wealth as the city enlarged its industrial nucleus. But Clarence Greenleaf White, another of Thomas's sons, chose a different direction. In 1898, Clarence relocated to Hastings, Florida, to establish a potato farm in a rural, agricultural setting. Moving to Redlands, California, he operated an orange grove while concurrently owning a pineapple plantation in Hawaii.

Rollin H. White, visiting his brother in Hawaii, envisioned the practicality of a motorized plow to increase the plantation's productivity. With financial assistance from Clarence, Rollin founded the Cleveland Motor Plow Company, located on Euclid Avenue at East 193rd Street in Euclid, Ohio. The venture remained independent of the White umbrella, since his family members demonstrated no interest in producing the farm vehicles. In this instance, Rollin's astute market instincts exceeded those of his family; nationwide, sales of the new vehicles called tractors increased from 2,000 units in 1909 to more than 200,000 units by 1920.

In 1917, Rollin renamed the business the Cleveland Tractor Company (Cletrac). Attempting to offset agriculture's extreme economic cycles, Cletrac manufactured an automobile called the Rollin. The experiment failed as Cleveland Tractor could not compete with the now-large automotive companies.

Rollin promoted his son, W. King White, to company president in 1930 while he assumed chairman of the board responsibilities. In 1944, Cleveland Tractor merged with the Oliver Farm Equipment Company; Rollin retired and moved to Florida. W. King White died three years later. The Catholic

Carmelite Sisters used Rollin's former Cleveland Heights mansion, located at the corner of Fairmount Boulevard and Lee Road, as a monastery. In 1962, the sisters constructed a new monastery on the same property. On September 10, 1962, Rollin died in his Florida home at the age of ninety.

In 1960, White Consolidated Industries purchased the Oliver Farm Equipment Company, uniting the heritage of Cleveland Tractor with the parent of White Motor, the company showing no interest in tractors nearly a half century earlier.

HALFRED FARM: A HUNTING VALLEY REFUGE

In 1916, while living on Lake Shore Boulevard in Bratenahl, Windsor White purchased a 715-acre Hunting Valley estate, including an 1839 vintage farmhouse he transformed into his country home. In the 1920s, Windsor enlarged the home, converting it into the family's year-round residence. Purchasing additional land, Windsor expanded the estate to 1,118 acres, encompassing both sides of the Chagrin River. Formerly called Huntington Place, Windsor renamed the property Halfred Farm, honoring his favorite hunt horse.

After Windsor retired from his business career, he participated in three African expeditions (1928, 1930 and 1937), donating hundreds of specimens and many reels of film to the Cleveland Museum of Natural History. Continuing his leisurely lifestyle, Windsor co-founded the Chagrin Valley Hunt Club, serving as master of the foxhounds for seven years. He promoted the sport of polo and, as a skilled horseman, actively participated in matches. Windsor expanded Halfred Farm, already housing a greenhouse and dairy, to accommodate his sporting interests. These additions consisted of an eight-acre, two-hundred- by three-hundred-yard polo field; a forty-horse stable; a blacksmith shop; and a kennel housing Norwegian wolf hounds.

At the age of ninety-one, Windsor remained chairman of the board of the Cleveland-based Park Drop Forge Company, reporting for work each day at the Union Commerce Building (Euclid Avenue at East Ninth Street). On April 9, 1958, in his brother Rollin's Florida home, Windsor died from complications created by an earlier stroke. The family conducted Windsor's funeral services in his Halfred Farm residence. After Windsor's death, his heirs divided Halfred Farms into four parcels. Much of this property has been restored by private investors and the village of Hunting Valley.

Mrs. Thomas White prepares for a stimulating fox hunt at Halfred Farms. *Courtesy of Cleveland State University, Cleveland Press Collection.*

THOMAS HOLDEN WHITE

In 1911, Thomas Holden White, the son of Windsor T. White, entered White Motor employment as an apprentice while attending University School. After graduating with a bachelor of science degree from Harvard, Thomas served in the military during World War I. In 1921, Thomas rose to vice-president of manufacturing for White Motor, resigning when his father retired in 1927. He entered the fields of investment banking and real estate, residing with his family in a house on Halfred Farm until 1948, when fire destroyed the property. Following the misfortune, the family continued to live on the estate, now sharing the home of Thomas's parents. Escalating the family tradition, Thomas attained national fame as a consummate polo player.

Thomas learned to pilot an airplane in 1940, purchasing his own aircraft in 1946. On October 26, 1951, with more than one thousand hours of

Thomas Holden White straddles a fence at the Chagrin Valley Hunt Club in 1947. *Courtesy of Cleveland State University, Cleveland Press Collection.*

experience as a pilot, Thomas took off from a private Hunting Valley airport with his wife and daughter-in-law. The three planned to meet former secretary of defense George Marshall for lunch in Washington, D.C. Approaching Washington National Airport, Thomas crashed his aircraft into the Potomac River, killing all three travelers.

The White story, to be fully understood, needs to include Thomas Howard White, the father of the three brothers, Windsor, Rollin and Walter, the founders of White Motors. Thomas came to Cleveland to produce sewing machines after the Civil War and was extremely successful, becoming the second-largest manufacturer of sewing machines in the world (Singer being number one). Thomas Howard, by all accounts, was a thoughtful man. He had a philosophy in both business and in raising his family. Thomas was raised by a manufacturing family, builders of furniture. At a young age, he wanted to go into manufacturing for himself. He determined that he needed to save some $600 to begin his business. It, however, is important to note that in actuality he only needed $300 to accomplish his goal. Why was $600 his number? Tradition of his day suggested that $300 went to Thomas's parents

to repay them for all that they had sacrificed in raising this fine young man. What a wonderful tradition this was! At this point, I must say I have four grown, wonderful children, all successful in their own rights today. As they left home, I do not remember any one of them giving me a big check for all the money spent on educating them. In polling most parents, I find that very few repayment checks were received. I for one would like to jumpstart this marvelous tradition between parents and their children once again.

Cleveland post–Civil War was already known throughout the country as a great center for manufacturing. Thomas Howard, with some of his relatives and a young family, migrated to Cleveland during this period to set up shop. As I am fond of saying, the rest is history. Success seemed to come quickly for the White family, and with such success, a move to Euclid Avenue, Millionaires' Row, was completed. I mentioned earlier that Thomas had a very definite philosophy, and the best I can do to explain this man's approach to life is with a few examples. One day, at the home on Euclid Avenue, the White sons were playing with large toy boats in a nice pond on the property. Imagine a nice pond on Euclid Avenue today. It seems that the older brothers each had their own boats to play with. The youngest, Walter, it appeared did not. Walter, being the youngest (ten years old) and the boldest of the brothers, decided to approach his father to make him aware of the situation. Attempting to be diplomatic, Walter asked, "Father, did you think about buying me my own boat?" Thomas immediately answered in the negative. Walter, never one to disrespect his father, walked away with some anger. Later, after some thought, he reapproached his father and said, "Father, I am going to build my own boat." Walter was somewhat surprised by his son's declaration and responded, "Son, I will buy you a good set of tools." Thomas Howard White wanted his children to be self-sufficient in this world. Indeed, he accomplished this goal.

A second important example of fatherly care is when Thomas brought his boys in to explain their use of his fine horses on the property. Thomas, like so many of the residents on Euclid Avenue, had some of the finest horses in the country. Thomas granted to his sons full use of these very expensive animals. He explained to them that their use was unlimited as long as they took extremely good care of the animals. He had them give their word, explaining that honor is a very important aspect of life and that it must be earned. He explained that honor lost could never be fully regained; thus, there were no exceptions in Thomas's world. If the boys didn't live up to their word, they would lose the use of these horses forever. There were no "time outs" in the world of White, and as his boys grew and owned hundreds

of animals later in life, each was taken care of much like these horses. I must say, Thomas's approach to parenting earned my respect. I believe all parents could learn from Thomas Howard White.

CIRCLE W FARM: A GATES MILLS HAVEN

At the time of his unfortunate death, Walter White lived on Circle W Farm, a 1,400-acre residence and working farm located in Gates Mills. White's twenty-three-room Georgian revival and Colonial home, built in 1923, featured a pillared portico resembling Mount Vernon. A wing contained the servants' quarters. The residence now houses the high school portion of Hawken School.

The estate, designed by Walker and Weeks and constructed between 1917 and 1924, contained a dairy herd, orchards, formal gardens, a greenhouse, a horse stable, a six-car garage and a dairy barn, the latter destroyed by fire in 1977. Mimicking his brother Windsor, Walter created a similar regulation-sized polo field. In 1928, the Circle W Farm hosted the National Inter-circuit Polo Championships and twelve-goal polo tournament, the first time a Midwest venue staged these national championships.

Walter White's Circle W Farm was of great interest to me in that today my home is on 6 of the original 1,400 acres that made up Walter's farm. The Whites believed in both farming and the planting of trees. Thus, today I own over one hundred of the most beautiful pine trees planted by the Whites some seventy years ago. The reason behind planting so many pines was so that future generations could enjoy them. Needless to say, I enjoy each and every tree.

There were a couple of events that took place in the 1920s at the Circle W that fascinated me and which I thought you might enjoy.

The first event involved a party during the summer involving maybe fifty to one hundred people. Mrs. White, as part of the refreshments, served southern-style mint juleps in very expensive silver goblets. The hit of the party turned out to be three Goodyear blimps, which arrived at Walter's request. Guests were treated with rides as part of the entertainment. I must say, our Cleveland Browns today are lucky to get one blimp to cover their games on occasion. Walter, however, got three in one day. The Whites took a blimp to a dinner in Akron, Ohio, and were brought home that night by their chauffeur, only to be greeted by a frantic house staff, twelve in all, suggesting

The Circle W Farm mansion. *Courtesy of the White family.*

to Mrs. White that many of her famous silver goblets were missing. Virginia, being very observant, suggested they look in all corners of the landscaped gardens, as many people had laid them down when they took their ride. Sure enough, all were found but one. Several months later, the last of the Whites' goblets was found behind the captain's seat in one of the blimps.

The second event of note involved a polo team traveling all the way from Spain to play on Walter's world-famous polo field. Walter's field was perfectly built, with full drainage, twelve inches of topsoil and a very special sod to withstand all the use such a field would undergo. The players arrived and stayed for some two weeks or more, playing against the Circle W team and other teams in the area, oftentimes in front of several thousand people. Early in their visit, as I understand it, Virginia White planned a large party to introduce the Spanish visitors to the valley society. Well, early that day, Walter and the boys played polo to exhaustion and went back to the home on the estate, set up for guests to spend the night and had a few cocktails. All men fell asleep on the floor. Mrs. White's party was over, and the host never appeared. I can only wonder about the conversation between Mr. and Mrs. White the next day. Needless to say, the marriage survived, as the Whites were a loving couple.

A Stroll Down Millionaires' Row

Epilogue I. White's Euclid Avenue Mansions

Following Thomas H. White's death in 1914, his 8220 Euclid Avenue residence served as a sanitarium before being razed in 1951. A used car lot occupied the site in the 1960s. Later simultaneously housing McDonald's and Popeye Chicken restaurants, the site is now home to a McDonald's restaurant and parking lot.

Henry Windsor White's widow sold their Victorian Gothic residence (8937 Euclid Avenue) after Henry's death in 1923. The home served as a rooming house, funeral home and a site for the International Center for Artificial Organs and Transplantation. Later owned by the Cleveland Health Museum, the former White residence is now part of the Cleveland Clinic campus. An adjoining carriage house served as a ballistics laboratory that contributed to the investigation of the Kennedy assassination.

After the razing of Rollin C. White's home (6619 Euclid Avenue), the site served as a used car lot but has remained vacant for decades. Situated directly east, a dilapidated, decaying industrial building has not been used since World War II.

Epilogue II. The White Sewing Machine Company

From the mid-1920s through the 1950s, White's original company supplied sewing machines to Sears, Roebuck & Company, using the names Minnesota, Franklin and Kenmore. Following World War II, the company encountered unrelenting competition from foreign-manufactured sewing machines, a few offering desirable features not available from U.S. manufacturers and nearly all less expensive to purchase. Sears, representing 40 percent of White's sales in the early 1950s, terminated its contract in favor of Japanese companies.

With sewing machine sales plunging, White entered a period of rapid diversification. In 1964, the company changed its name to White Consolidated Industries, reflecting its expansion by purchasing the home products divisions of Westinghouse, Frigidaire, Philco, Kelvinator, Gibson, Hamilton and Franklin. In 1986, Swedish-based Electrolux acquired White Consolidated Industries. The White-brand sewing machine ended production in 2006.

An employee demonstrates the capabilities of a White sewing machine during a 1933 open house. *Courtesy of Cleveland State University, Cleveland Press Collection.*

EPILOGUE III. THE WHITE MOTOR COMPANY

Robert Woodruff, no longer a White Motor employee in 1929, had once progressed within the company from salesman to vice-president. As a stopgap measure to counteract Walter White's unanticipated death, Woodruff assumed the presidency of White Motor while continuing his career as president of Coca-Cola. Within one year, White's board of directors selected outsider Ashton Bean as the new president of White Motor, an organization now fighting for survival during the Great Depression. Bean slashed overhead costs but sacrificed the employee goodwill fostered by the White family since the company's inception. Employees responded by organizing one of the nation's first automobile unions. Motivated by panic, White Motor entered into an ill-fated, short-lived merger with Studebaker in which neither organization generated synergies to create cost savings.

In 1935, White's new president, Princeton-educated Robert Fager Black, began molding a remarkable company turnaround. Although never

previously a White Motor employee, Black understood and reestablished the previous company culture. He learned employees' names, often visited the manufacturing operations and implemented a genuine open-door management policy. During a union strike, he provided workers walking the picket line with baseballs and bats to alleviate their boredom. The workers responded by mowing the company's lawn.

Black, a former vice-president of Mack Truck Company, restored company profitability, earning the praise, "Black took White out of the red." In 1956, after serving as president for twenty-five years, Black became chairman of the board. Ten years later, at the age of seventy-six, he retired from his office on the thirty-first floor of Erieview Plaza. During Black's thirty-one-year tenure, White Motor's sales grew from $19 million to $628 million, an increase of 3,205 percent.

After World War II, White Motor streamlined its operation to manufacture only large trucks. A sales decline in the late 1960s prompted White Motor to attempt a merger with White Consolidated Industries, but the federal government prevented the unification. Because of the company's poor financial performance, the government acquiesced in 1976; the two companies joined after six decades of separation. In 1981, Volvo acquired most of the truck assets of the insolvent White Consolidated Company. Six years later, Volvo purchased General Motors' heavy truck division, soon terminating the White brand.

Today, one last remnant of the White Motor Company still remains. In the 1930s, White produced five hundred specially designed buses to transport sightseers through the national parks in the western United States; the distinctive vehicles are famous for their rollback canvas convertible tops. A few of these original buses still operate in Glacier and Yellowstone National Parks.

One final event will serve to close out this chapter. It occurred during a beautiful morning in September 1928. This was a Saturday morning, a workday for Walter at the White Motor Company, which was located at East Seventy-ninth and St. Clair Avenue, Cleveland, Ohio. From his home, Walter made this trip every morning for his meeting at 8:00 a.m., traveling a distance of fourteen miles in about ten minutes. If you are wondering, his speed was eighty miles per hour. For you see, Walter for a time was a racecar driver for White Motors.

In many quotes, Walter said speed was in his blood, a feeling that never went away. Daughter Mary used to say that her father reached eighty miles per hour in their long driveway when coming home at night. Although Walter took different routes to work in the morning, this particular day he

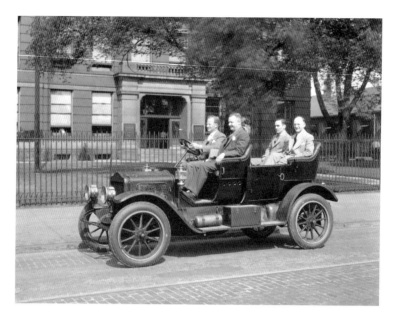

In 1930, company executives take a ride in a still-operational 1905 White Steamer. *Courtesy of Cleveland Public Library, Photographic Collection.*

In 1942, pinup movie star Dorothy Lamour visits the White Motor plant to inspire workers and plug her film *Road to Morocco. Courtesy of Cleveland State University, Cleveland Press Collection.*

would take Fairmount Boulevard, as he was going to pick up his secretary on his way. At eighty miles per hour, he approached a dangerous intersection, Fairmount Boulevard and Green Road. Not seeing an oncoming car due to a large sign on the corner, Walter proceeded at full speed. A Ford Model T hit Walter's car, sending it flying through the air. Walter also went flying, landing some fifty feet away. Most bones in his body were broken, and he suffered from extreme bleeding. He was picked up with care and was taken to Lakeside Hospital, where they almost managed to do the impossible. Surrounded by his complete family and talking of the future to Virginia, he was given a final blood transfusion. At about 3:00 a.m., Walter passed away at age fifty-three.

When I began my research on Walter White and his great Circle W estate in Gates Mills, Ohio, I came across a fascinating story buried in the family archives. Walter White, it seems, due to his great expertise in the transportation industry, was selected by our allies in World War I to head up the coordination of all mechanized vehicles to be used in the war effort.

Walter's job was endless, keeping in mind that most countries at this time, including the United States, were still using horses and mules for their transportation needs. Thus, Walter had to coordinate vehicles and parts departments with the training of mechanics to make sure one could be counted on for the war effort. As a businessman today, I look upon what Walter accomplished with amazement. I believe the task would have bordered on impossible even in peacetime.

Doing what he did during wartime, in my opinion, bordered on genius. The result of the war speaks for itself, as Walter's successes were nicely documented in the family archives. As a former American history teacher, I was struck by the fact that none of this information appeared in any of my history books. Walter White, through his work, again showed the greatness of Cleveland, Ohio, during this time period. There was not too much going on in the world at that time in which Cleveland was not involved.

Walter White did make the history books—just not in the United States. The country of France awarded Walter one of its highest medals, presented to those who have distinguished themselves in their own particular fields during wartime.

Walter received many other honors, but my favorite was when he was made an honorary colonel in the Toronto Scottish Regiment by the Canadian government. Officers above a certain rank in this Scottish regiment were assigned a piper for life, and in return, the officer and his family would buy the piper his pipe and his kilt uniform and provide

Above, left: The White Book, In Memoriam. Courtesy of the White family.

Above, right: The White Book, In Memoriam. Portrait of Walter C. White. *Courtesy of the White family.*

transportation for him to play at any family function, such as weddings, birthdays and, sadly, funerals.

It appeared Sergeant Major Thompson was a perfect fit for Walter in that he was a character of sorts. He had a glass eye that replaced an eye lost in the war. He loved to drink champagne, not for the taste but for the result of the drinking. It is said the glass eye would glow when he drank and thus scare most children who saw him in such a state.

Walter's piper, as best we could tell, did not play much for the White family during the 1920s.

With Walter's tragic death in September 1929, Virginia White, now a young widow with five children, two of whom had died at two years of age, had to plan a funeral for her husband. Mrs. Virginia White invited piper Thompson to head up the funeral procession of over one thousand people as they laid Walter to rest at a small local cemetery not far from the Hunt Club Walter loved in Gates Mills. Having attended a funeral with a piper, I can only imagine the emotions of that day.

Thousands of people showed up; a long procession was planned, starting at St. Christopher's Church, located across the street from the Hunt Club (where Walter was a founding member), and heading to a cemetery located on River Road in Gates Mills. They proceeded down River Road one mile to the small Gates Mills Cemetery, led by the sergeant major.

The mourners walked and put Walter to rest. Virginia White remained at the Circle W for the rest of her life, passing away in 1958 at age sixty-nine. Today, the White property is home to a fine private prep school known as Hawken High School. Walter White Jr. attended this school. Walter White was the last of the White family to be associated with the world-famous White Motor Company.

The following is a rare copy of the White Motor booklet put out by the company upon Walter's death. This written word, I believe, will give one great insight into the White family and the company they founded:

Walter C. White

The bewildering suddenness of the death of Walter C. White, our president and chairman of the Board of Directors, leaves us groping for words adequate to express our sorrow.

Great as our loss is, however, we must submerge our personal feelings in an expression of sympathy to Mrs. White and their children in their greater loss.

In his death, we have lost a leader who was ever an inspiration, and a friend whom we have learned to Love.

The highest tribute we can pay him is to carry on the work to which he devoted his Life by keeping the name of White foremost in its field.
—E.M. Smith Jr.

Death found him as he faced his foes,
Clear eyed and unafraid.
Courageously his spirit goes
Into the mortal shade.
He laid him down like a banner torn
In battle, like a rapier worn
To the hilt in the fight for free man born—
Calmly and undismayed.

The path of glory ends; the bier
Awaits his last repose.
His race is run, his record clear—
How clear the Lord God knows,
He's had no mourning, while regret,
He stood apart from the world—and yet
A tower has fallen, a star has set,
Though the light from the star still glows.

—Nelson Robins

Walter B. White

The death of President Walter C. White on Sunday morning, September 29th, has cast a shadow of sadness over the entire home and field organizations. His qualities of leadership had won for him the love and respect of those who worked under him, and they feel keenly their loss.

Mr. White was fatally injured when his automobile collided with another at Fairmount Boulevard and Green Road, Shaker Heights, about eight o'clock Saturday morning, while he was driving from his Gates Mills home to the office. Although suffering intense pain, he displayed characteristic courage, directing motorists who had stopped, to notify his secretary, Miss Catherine Reilley. He then requested that Mrs. White be spared all knowledge of the accident until the extent of his injuries could be learned.

He was taken to Lakeside Hospital, as he had directed. There he was met by Dr. G.F. Sykes, company physician, who, with several of the city's foremost surgeons, fought to save his life. In spite of all that medical science could do, however, Mr. White was unable to withstand the serious injuries he had suffered, and died at three o'clock Sunday morning. His wife, his sister, Mrs. Horatio Ford, and two brothers, Windsor T. and Rollin H. White, and their wives, were at his bedside when he died. The third brother, Clarence G. White, lives in California, and was, therefore, unable to be present.

Walter C. White ranked as a pioneer in the automobile industry along with Alexander Winton, Henry Ford, Elwood Haynes, Jonathan D. Maxwell, Elmer Apperson, Benjamin Briscoe and James W. Packard. He had been a leading manufacturer from the advent of motor trucks and busses, and was one of the first automotive manufacturers to point out the advantages of co-ordinated motor and rail transportation.

He was a recognized world authority on highway transportation. This position in his field was emphasized recently when President White was called to Washington to appear before a sub committee of the United States Senate's Finance Committee at a hearing to consider the discontinuance of the twenty-five per cent ad valorem duty on motor trucks and busses exported to other countries.

It was in New England, amid the struggle with early mechanical problems, that the present White industry came into being. In 1859, at Phillipston, Massachusetts, Thomas H. White, the father of Walter C. White, began the manufacture of sewing machines. The demand for sewing machines sent him to Orange, Massachusetts, to open a larger factory, in 1863. Seeking a still broader territory, he moved to Cleveland, Ohio, in 1866.

Ten years later, 1876, the White Sewing Machine Company was organized as successor to the White Manufacturing Company. It was in this year, on September 8th, that Walter White was born, the next to the youngest of eight children.

His parents were then living in a house located at the corner of Perry (now East 22nd) Street and Scovill Avenue. When he was two years old the family moved to a new home on Euclid Avenue near what is now East 82nd Street. It was then "out in the country," and Mr. White grew up knowing all the delights of outdoor life, developing his fondness for horses and for hunting which he never outgrew. Mr. White attended local schools and graduated from University School in 1894. He entered Cornell University with the Class of 1898, taking a general science course, but during his last year he became interested in studying law.

Mr. White did not step right from college to the presidency of the White Motor Company. He traveled the long, hard road of experience before reaching the top. The summer after graduation he started to work at the White Sewing Machine Company as assistant to the assistant treasurer. This position did not hold his interest long, and he admitted he was a "fish out of water."

After a few months as an unpromising bookkeeper, he went to New York and concentrated with such determination on "reading" law that he obtained his degree the following spring, and a year later was admitted to the bar. Thereupon he entered the office of Judge Williamson, general counsel for the New York Central Railroad.

"I had no false notions of my ability," Mr. White once said in recalling the incident. "I stayed in Judge Williamson's office through the summer, and by fall I knew I was on the wrong track again."

Back to Cleveland he went, to work in his father's factory, this time in the shop, on engines, first testing, then producing them, for the sewing machine firm was now manufacturing automobiles. Like his brothers, Walter White had always been interested in making things and in understanding how they operated.

He had been employed thus for only a short time when someone was needed to sell Whites in London. Before actually selling them, indeed, it was necessary to prove to the skeptical public of that day that they would actually run. Walter White was selected. He was only twenty-five years old and had had little that could be called selling experience. He once said that at that time he did not know how to talk in sales language, and that the most conspicuous display in his first showroom in London was his own ignorance. He remained in London three years, however, and by the end of that time the White car was well known. As a test of reliability, he offered to haul the royal British mail through London daily and did it for three months. The British were delighted with his performance, but, instead of giving him a contract for cars, wanted him to continue hauling the mail.

In the fall of 1901 the output of cars was three a week and the motor manufacturing department was occupying a small plant just outside the factory of the White Sewing Machine Company. It was in this year that the first White passenger steam cars were produced. The following year the first White delivery van was built and sold.

By 1906 the company had an output of 1,500 cars a year, which was about twice that of any other manufacturer of large touring cars in the world. The time had arrived to organize the automobile end of the White Sewing Machine Company's business as a distinct corporation, so on November 19, 1906, the White Company was organized, and Mr. White was elected vice president. On May 7, 1921, he was elevated to the presidency.

The White Company became the sales subsidiary when, on December 23, 1915, the White Motor Company was organized.

In the early days of the automobile business demonstrations necessary for promoting sales were far more strenuous than today. Long trips over uncharted roads, hill climbing contests, races and reliability runs were necessary to make people believe the automobile was a practical machine and not a makeshift. Endurance tests were almost daily events, and the car with the greatest speed, coupled with hill climbing ability, naturally won its way into great prestige. The White Company never missed an opportunity to enter a car in a race or hill climb, and almost invariably a White was first under the wire.

152

Walter White was not the type of man to sit in his office and direct sales, but was in the thick of these picturesque events, speeding around the track, or with mud-spattered clothing, pulling into a checking station on a reliability run. In many of these contests he piloted his car to notable victories. In 1905, he drove a White from Chicago to St. Paul, 499 miles, in forty-three hours and thirty-six minutes, arriving at his destination forty hours ahead of his nearest competitor. In 1907 Mr. White won the Hower trophy in the Glidden reliability tour. In the same year he sat at the wheel of a White steamer and drove it roaring up the Stucky Hill near Brecksville, to win first place in the annual Cleveland Automobile Club test drive. His time for the hill was thirty-two seconds.

Mr. White's first try at racing was in the Vanderbilt cup race on Long Island, in 1907. His second was held in Cleveland. He had a great desire to have his father see him win, so he went into it for all he was worth, and clipped six seconds off the record.

An accident finally took him from the driver's seat of his racing car and placed him behind an executive desk. In a race held at Cincinnati, the car he was driving skidded on a cement cross-walk and turned over. Mr. White was underneath the car and when he was pulled out he was found to have a broken leg.

During the World War, Mr. White was appointed chairman of a committee to go to France to assist in organizing the repair and maintenance of motor vehicles in military transportation. In recognition of his services and the important part White trucks played in winning the war, the French Government conferred upon him the highest honor it can give a civilian, making him a Chevalier of the Legion of Honor.

On September 25, 1919, Mr. White was married to Miss Mary Virginia Saunders of Statesburg, South Carolina, who survives him. They have five children. Ann Heron, Mary Greenleaf, Walter Harrison, Martha Wells, and Catherine Coryton.

President White lived at Circle W farm at Gates Mill, seventeen miles from Cleveland. He was greatly interested in practical farming and insisted that his farm be something more than a country residence. Under his management, it was celebrated for its produce. The White stables are ranked with the best in the country, and the White home has long been a popular gathering place for America's foremost polo players.

At the time of his death, Mr. White was president and chairman of the Board of Directors of the White Motor Company, the White Company, the White Motor Securities Corporation, and the White Motor Realty

Company. He was a director of the Union Trust Company and the Bishop & Babcock Company of Cleveland, and the Coca Cola Company of Atlanta, Georgia.

He was a member of the Society of Automotive Engineers; fellow for life of the Cleveland Museum of Art, a member of Alpha Delta Phi fraternity, and the Union, MidDay, Hermit, Tavern Country, Kirtland and Chagrin Valley Hunt Clubs of Cleveland; the University, Metropolitan, Recess, Cornell, and Engineers' Clubs of New York; the Ottawa, Ohio, Shooting Club, the Maganissippi Club, Canada, and the Norias Shooting Club, Georgia.

Mr. White was buried at Gates Mills, Tuesday afternoon, October 1ˢᵗ, in the churchyard of St. Christopher's by the River, after a simple service at the church, in which Mr. and Mrs. White were very much interested. Bishop Coadjutor Warren Lincoln Rogers of the Episcopal diocese of Ohio, conducted the service, assisted by the Reverend J. Frank Jackson, rector of St. Christopher's.

The pall bearers were Windsor T. and Rollin H. White, Mr. White's brothers; Thomas H. White, W. King White, Holden White, and J.A. Harris. Jr., nephews: Horatio Ford, a brother-in-law, and Warren G. King and Herman Vail, husbands of his nieces.

Besides many employees from the plant here, automobile men from neighboring cities, a large delegation from the National Automobile Chamber of Commerce, and representatives of Cleveland industrial and civic organizations attended the funeral.

As a mark of respect, the White plant and White district and branch offices throughout the country were closed the day of the funeral.

Tribute was paid to Mr. White in editorials in the Cleveland Plain Dealer *and the* Cleveland News, *and in statements by City Manager W.R. Hopkins and Allard Smith, president of the Chamber of Commerce, showing the high esteem with which Mr. White was held in the community.*

The Plain Dealer *said in part, "He had marked capacity as a business man, an executive and a financier, and under his presidency The White Motor Company grew and expanded. While the independent companies organized by Haynes, Apperson, Maxwell and Briscoe long since were driven out of existence by severe competition, the name of White still lives in the industry. Walter White's death at fifty-three is most untimely. He was a man Cleveland can ill afford to lose."*

"Cleveland has lost an outstanding citizen," was Allard Smith's comment. "Its industry and business loses a great leader. Mr. White was always ready to support generously, with his time, thought and finances,

every worthwhile community endeavor. His delightful personality and true friendship we shall ever cherish."

City Manager Hopkins said, "The death of Mr. White is a terrible loss to the city. He always carried more than his share of the load. He made an especially large contribution to everything looking toward the improvement of our highway system. To those who enjoyed his personal friendship, his death is a most profound shock."

Directors of the American Electric Railway Association, in convention at Atlantic City, passed resolutions of respect and regret.

Thousands of telegrams of condolence were received from business leaders in all parts of the world, both within and without the automotive industry. Floral tributes came from all parts of the United States.

THE FLOWERS OF THE FOREST

I've seen the smiling of fortune beguiling,
I've tasted her pleasures and felt her decay;
Sweet was her blessing and kind her caressing,
But now they are fled, they are fled far away.
I've seen the forest adorned the foremost,
Wi' flowers o' the fairest baith pleasant and gay,
Sae bonnie was their blooming, their scent the air fuming.
But now they are wither'd and a' wede away.

I've seen the morning with gold the hills adorning,
And loud tempests storming before parting day;
I've seen Tweed's silver streams, glitt'ring in the sunny gleams,
Grow drumlie and dark as they roll'd on their way.
O fickle fortune! why this cruel sporting?
Oh! why thus perplex us, poor sons of a day?
Thy frown cannot fear me, thy smile cannot cheer me,
Since the flowers of the forest are a' wede away.

—Mrs. Cockburn

The music of the old Scottish Lament, "The Flowers of the Forest," was played over Mr. White's grave at the funeral by Sergeant Major Piper Alexander Thompson of the Toronto Scottish Regiment, of which Mr. White was an honorary member.

155

Conclusion

When all is said and done, history, I believe, plays a most important role in the evolution of society. In recent times, it appears that in our schools the subject of history may have become less important than in the days when I went to school. If true, what a sad testimonial of our times. It is the hope of my coauthor, Alan Dutka, and myself that you, our reader, attained enjoyment and knowledge from what you have read here. Those of us who are Clevelanders perhaps now will hold up our heads a bit higher knowing some of this great Cleveland history. Such would make Alan and me extremely happy.

To conclude, I thought I might end our adventure together with a short story that was actually told to me by a member of my audience after one of my presentations. This story is significant because it truly marked the end of Cleveland's Millionaires' Row. The sadness in all of this is that Cleveland's heyday lasted only about four generations, ending, it seems, with our country's Great Depression. Never again will such a grand time, with its over-the-top lifestyles, happen. Maybe the huge fascination of the period is due to the length of time it existed; yet so much was accomplished in this short time. Today, of the more than 250 mansions along Euclid Avenue, only four remain as a true reminder of our grand past. The following is the story of the destruction of one of Euclid's finest homes ever to grace this famous avenue.

The year was 1929, and a wrecking crew was about to tear down the old Charles Brush mansion located between East Thirtieth and East Fortieth Streets on Euclid Avenue. Charles Brush, a co-founder of the General

Electric Company in Cleveland, Ohio, had put in his will that the mansion be destroyed upon his death. We may note here that some Euclid Avenue patrons had their homes destroyed upon death, not because they were afraid of another family moving in, but rather because they did not want their homes used for commercial purposes as many were. The teardown was about to start when the crew noticed a beautiful limousine coming up the driveway. All eyes were fixed on this expensive auto as an elderly gentleman exited. Well dressed, this man for a time just stood and looked at this grand old home. After a moment or two, our unknown fellow sought out the foreman on the job and asked if he could go inside for a short moment.

A short while later, our mystery person came out of the home, went directly to the foreman and asked for a screwdriver. One was found and given, and the gentleman went into the home again. Several minutes went by before the man exited the mansion with a crystal doorknob in his hand. The doorknob was probably very valuable, but this was not important, for our stranger already had more money than he could spend. He returned the screwdriver, thanked the foreman and got back into his chauffer-driven black Lincoln limousine. Our stranger was then on his way back to Detroit, Michigan. The Charles Brush homesite eventually became the home to a new Cleveland Arena, designed to service a professional hockey team. Our Cleveland Cavaliers used this arena as their first home.

Oh, by the way, our mystery stranger was none other than Henry Ford. Henry Ford, Charles Brush, Thomas Edison and Harvey Firestone were the best of friends who went on camping trips for years to enjoy friendship and the wonders of nature. One can only imagine the discussions that these four great characters had at this point in their careers. One can only wonder.

ABOUT THE AUTHORS

Former high school history teacher Dan Ruminski gives over ninety presentations a year on Cleveland's 1875–1929 history and runs www. Clevelandhistorylesson.com. Ruminski also owns Martinson-Nicholls floor mat distributors.

Cleveland native Alan Dutka authored *East Fourth Street: The Rise, Decline, and Rebirth of an Urban Cleveland Street*, with Cleveland Landmark Press, as well as four business books.